The Writer's Brush:

An Exhibition of Artwork by Writers

The Writer's Brush
An Exhibition of Artwork by Writers
thewritersbrush.com

Anita Shapolsky Gallery
152 East 65th Street
New York, NY 10021
ashapolsky@nyc.rr.com
212.452.1094
11 September 2007 – 27 October 2007

Pierre Menard Gallery
60 Kilsyth Road
Brookline, MA 02445
duck@lameduckbooks.com
617.407.6271
5 December 2007 – 20 January 2008

Published by Anita Shapolsky Art Foundation
152 East 65th Street
New York, NY 10021
First Edition 2014

ISBN 978-1-4675-7558-4

Catalogue design by Chris Shultz

The Writer's Brush:
An Exhibition of Artwork by Writers

Donald Friedman & John Wronoski

Introduction by
Joseph McElroy

Contents

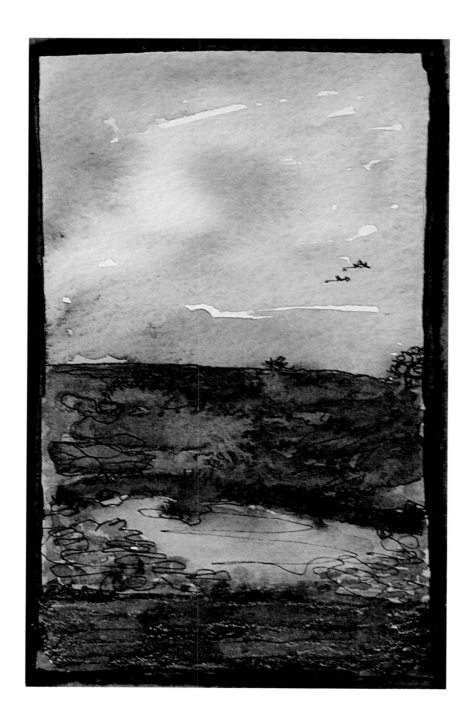

right:

Jim Crace
River, c. 2002
Watercolor on paper
7" x 4"

Courtesy of the Artist

Foreword

Donald Friedman

In the preface to my recently completed book, *The Writer's Brush: The Paintings, Drawings and Sculpture of Writers* – which I endeavored to make as comprehensive as possible, identifying more than 260 writer-artists and reproducing more than 400 images of their work – I had presciently acknowledged that "with new writer-artists appearing every day, it was out of date the day it was published." But I little suspected that not two months after it had gone to the printer in early 2007 I would be inundated with names of writer-artists who had escaped my notice.

I write both thrilled and slightly abashed at having discovered – in mere weeks, and almost entirely through John Wronoski, proprietor extraordinaire of Lame Duck Books and Pierre Menard Gallery – dozens of writer-artists I'd failed to unearth in a decade of research. I can understand how virtually no one (except, somehow, John) would know that Annie Proulx keeps a notebook of watercolors, or that Jim Crace relaxes with paints as well as birdwatching. But how could Rosanna Warren, a chancellor of the American Academy of Poets whose biography boasts a degree in painting from Yale, or two-time National Book Award-winner A.R. Ammons, whose paintings had been prominently exhibited, have slipped under my radar?

Poet Susan Howe's graduation from the School of the Museum of Fine Arts, Boston, was not widely advertised; nor were Annie Dillard's years of painting after college. Roberta Allen, however, has made no secret of her twin gifts, exhibiting her museum-collected art internationally for decades; and Marjorie Welish, one of the rare equal talents, taught art and art history at Pratt even as she lectured in poetry at Cambridge and Brown Universities.

Such omissions were happily, if only partially, remedied by inclusion in this exhibition and documentation in this catalogue. (An open-ended repository for identification of writer-artists and artworks, to which anyone may contribute, has been set up at www.

thewritersbrush.com.) Perhaps more importantly, recognizing these additional creative spirits validates the premises of my book: that writing and art are allied crafts, that expression in word and image by a single soul is not so odd, and that it is of interest when it occurs.

There had not been a major exhibition of writer-art in the United States (or anywhere else to my knowledge) until Rue Shaw curated "A Second Talent" in 1971 at the Arts Club of Chicago and, until "The Writer's Brush" exhibition at New York's Anita Shapolsky Gallery and its reprise (with considerable additions) at Pierre Menard Gallery, both in 2007, there had not been a major one since. The phenomenon of the multiply-gifted has not been readily accepted in this part of the world, where we seem to prefer our creative types to declare themselves one thing or another. In Europe, however, there is a long tradition of respect for the writer-artist, and one can find the paintings of, for example, Jean Cocteau, George Sand, Mina Loy, or Eugene Ionesco, as well as of contemporaries such as Peter Sacks, Gao Xingjian, Breyten Breytenbach, and J.P. Donleavy in the best galleries.

When I got the notion to assemble an exhibition of writer-art, my intention was mainly to display works by some of the 200 writers I'd featured in *The Writer's Brush*. I also thought it would be an opportunity to showcase some of the sixty-odd writer-artists I'd been forced to list "among the missing," largely because I'd been unable to secure a work or a reproduction permission. What I hadn't imagined was that the process of sussing out material for the show would uncover enough additional writer-artists for a new edition of the book.

Since many of my subjects' works are warehoused in museums and libraries that lend only to equivalent institutions, I had to borrow from private collections. Fortunately one of my first stops in 2007 was John's store. I had visited his shop years earlier to examine its inventory of paintings and drawings by writers, but John, who lives at the intersection of literature and art, was travelling and I had unwittingly missed the opportunity of exploiting his wide knowledge. During our first phone call, as the pages of *The Writer's Brush* were rolling unamendably off the presses, John casually named about twenty writers he knew to be painters, none of whose second talent I'd been aware of. After years of developing relationships with other buyers and sellers of writer-art and with many writer-artists themselves, he also had the confidence of its collectors – a critical matter when persuading them to lend to a show.

above:
J.P. Donleavy
Beast, 1977
Watercolor on paper
7 ½" x 11 ¾"

Courtesy of Nick Lawrence

Artwork by Writers

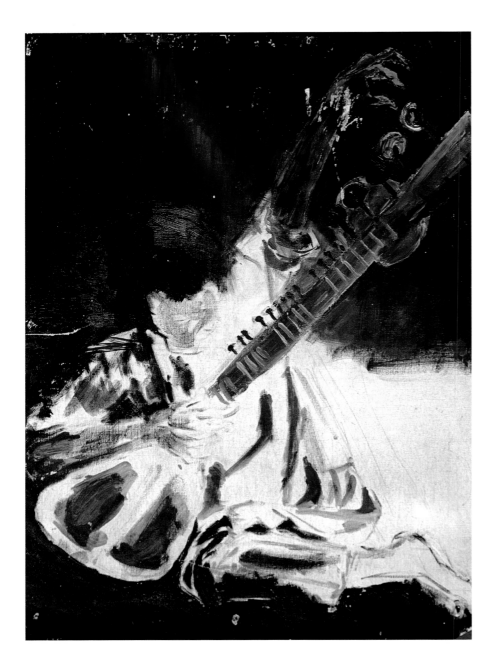

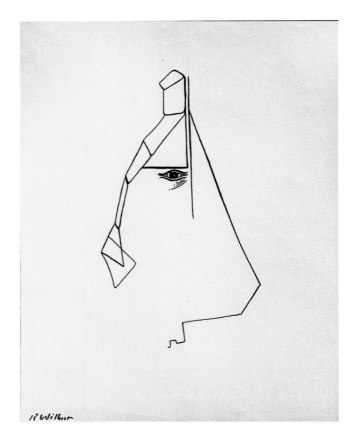

left:
Maxine Hong Kingston
Ravi Sankar, n.d.
Oil on paper
20" x 15 ½"

Courtesy of the Artist

above:
Richard Wilbur
Untitled (Head), n.d.
Ink on paper
11" x 8 ½"

Courtesy of the Artist

The Writer's Brush

Besides the pleasure of viewing works by newly-revealed writer-artists and artworks featured in *The Writer's Brush* in their original form, the visitor to the galleries was able to see additional, exceptional works by the book's subjects. Enid Bagnold's family, for example, dug deeper and found an accomplished etching and a charcoal sketch done in Walter Sickert's studio – perhaps at the very moment when the great impressionist and notorious lecher was stealing one of the kisses about which she wrote so dismissively in her diary. Maxine Hong Kingston, who had lost her paintings in the 1991 Oakland fire, happily continued her visual art and supplied a watercolor on glass, an oil, and two "enzos," highly evocative ink on paper pieces done with a Chinese calligraphic brush. The enigmatic Russell Edson delivered to the gallery significantly more complex and sophisticated etchings than the drawings that typically accompany his prose poems. And Richard Wilbur mined personal archives for his early cubist-influenced drawings.

Patti Smith's charming early style of drawing, reflected in the portraits of herself and Sam Shepard that appear in *The Writer's Brush*, was replaced after 9/11 by the keening lines of her twin tower series and most recently by the exhibited drawings that incorporate words with no meaning beyond the shape they make on the page. As the artists evolve, so does their art. And, over time, each generation of creative originals is supplanted by another. This show is not so much a gathering of the past as it is a snapshot, a freeze-frame moment in an endless stream of creativity that began with humankind and will end only when we've done ourselves in. From Hugo to Huxley to Smith, we are presented with writers who, in the words of writer-artist Max Jacob, exteriorize themselves by their chosen means, and it may be by whatever means is at hand. Here it's not poetry but paint, not metaphor but matchsticks, not irony but ink brush.

above:

e.e. cummings
Untitled Portrait, c. 1935
Oil on canvas-board
17" x 14 ½"

Courtesy of Justin G. Schiller

The Writer's Brush

Untitled

Joseph McElroy

I have tried it, though not doodles like Lawrence Durrell's in his notebooks or Kafka's streamlined art nouveau sketch of a speeding runner. But a face I try again and again, inept, vulgar, as far from what I want as a bad cartoon. This was the real talent, I used to think, told as a kid that either you had it (as a school friend of mine clearly did), this knack, this power to draw – or you didn't. He could draw anything, we would say. Realistic, we meant, those World War II GIs, the folds of their fatigues so true to life it was uncanny. What could I have done to have the gift?

"All things can tempt me from this craft of verse," said Yeats (*in* verse), only to note that distractions once upon a time like Maud Gonne's face and the fate of Ireland turned out to be his very subjects. Yet he wishes ironically that he could have back the inarticulateness of those early apprentice days. Inspired also by visual art, Yeats also tried his hand at it. Hardly unusual for a writer. A change of mood. A scene. Passing time. A way of thinking apart from words, if not accompanied or interrupted by them.

The subject is of interest, though elusive, and this gallery show *The Writer's Brush*, excerpted from and advertising the book of the same title, Donald Friedman's anthology of visual art made by writers, bears in its population and peculiar society of images material for questions more telling than the mere fact of all these writers making paintings and drawings (and evidently glad to have them on view).

What is this act, this alternative? And is it different for a writer, this impulse of the hand *and* eye, this pleasure, comfort, handiwork, this reach, making one kind of mark instead of another, this coupling across arts or departure from one for the other? Brief notes in Friedman's book are briefly entertaining – and suggestive. For Strindberg not a brush but a palette knife and the satisfaction of finishing a landscape in two or three hours. Painting was like breathing, of course, for E.E. Cummings, that air-conditioned soul whose paintings and poems, he said, "love each other." A range of motives and

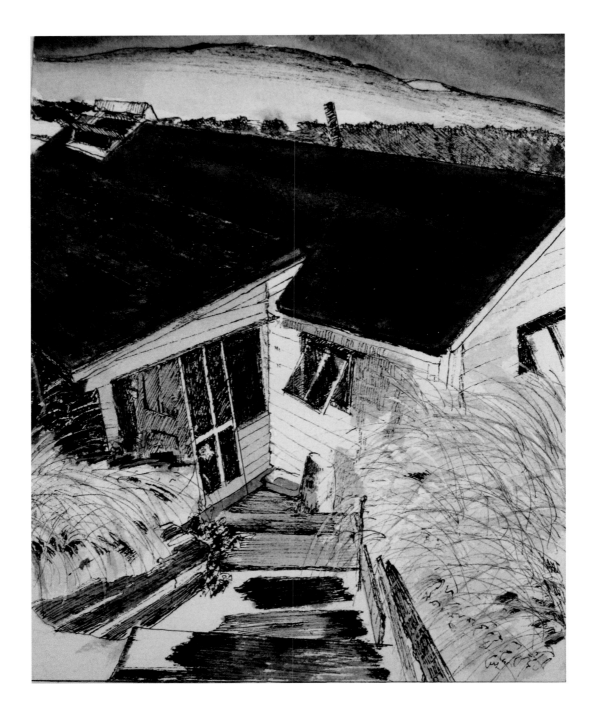

fulfillments one may suppose associated with this parallel path taken into visual art – by, though, I keep thinking, a *writer*.

This one collective fact of the show seems also a shadow cast by it and upon it, a virtual library or multifarious miscellany of written work that both is and is not present here, mysterious if even knowable in its relations to these pictures. Even Yeats's blue, delicately amorphous crayon impression of Coole Lake, which I suppose is happy to lack the major multiplicity captured in his poems' symbolism of that place and its swans.

Or is it not a path taken but exists and had no beginning? As perhaps with Jean Arp, who was probably first a sculptor and collagist. Or Mina Loy, who "tried" everything and may have turned from other arts to writing, which in fact brought her a second, posthumous fame. A part-Cubist crayon portrait by Robert Duncan suggests frontally not so much the fullness of filial conflicts in his brave and almost uncharacteristically incisive poem "My Mother Would Be A Falconress" as a pivoting of multiple identity. Passing celebrated names, I wonder if there is something for me to find in a painting by the Spanish Communist poet and playwright Rafael Alberti, whose writing I do *not* know. That he was primarily a writer not a fact you would divine from the image – which I will "read" for maybe the suspicion of a story, a mixed feeling, a route taken, a byway.

Away from yourself for a while. To be not this person sifting, building, composing words, but with a quick (even slow) hand describing directly onto a quite differently empty (and coverable) surface a shape, the thing itself almost. Do I believe that? Does it go against writing? To render nature by painting – a skeletal winter tree, bare thigh, sea surface – can seem as much more direct as it seems more tangible than in words. Which are put in their place as merely "the daughters of earth" when compared to "things [which] are the sons of heaven," in Dr. Johnson's Preface to his diary-like *Dictionary* – though in 1755 he meant God's creation, not things depicted.

Where in Annie Dillard's drawing that close silence awaits of what is seen, those steps, those grained textures of wood and roof which might be a relief from the intensity of her prose; as Donald Justice's intersecting roofs with (for me) a close remoteness of de Chirico translate some tightness of his verse. Tennessee Williams's dark blue, touching, yet routine waterscape with house, puts a distance almost fleetingly soothing

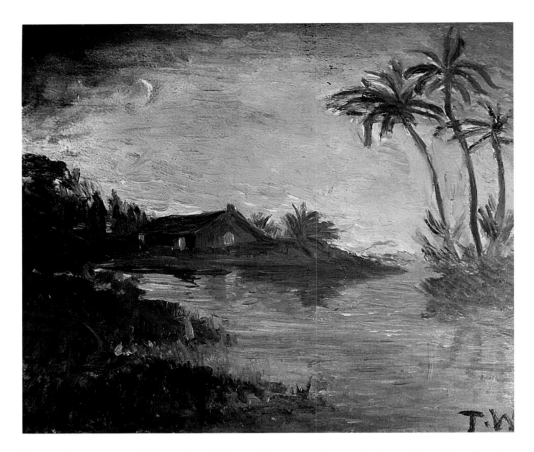

right:
Tennesee Williams
Tropical Scene, n.d.
Serigraph from a 1928 oil
painting, signed
17 ½" x 18 1½"
Collection of Donald Friedman

between him or us and the words of his stage language, that onslaught and invasion of stories surprising with their yearning wit and rawness. To be free of the very sound of words, their rhetoric, if not their sense, would be the thing.

Trying a drawing, two drawings, couldn't there be for a writer a vacation or freeing from the pressure to be good, the knowledge of what you can and can't do (in fiction with all its rules, even in free verse, which Robert Frost glibly called playing tennis without a net)? A chance to slip the prideful constraint of craft by assuming the flare and folly of a beginner. The New York painter Barbara Ellmann tells me that during her first career as a member of a dance company often on the road she filled notebooks with sketches whenever she had a chance. Looking ahead but in the moment exploring for herself the possibilities of making something else, without worrying yet about rules. Half-consciously preparing for her second life as a painter and sculptor with what you could call a freedom, letting things emerge, the freedom of a beginner. With that readiness which, as we are reminded by Shunryu Suzuki in *Zen Mind*,

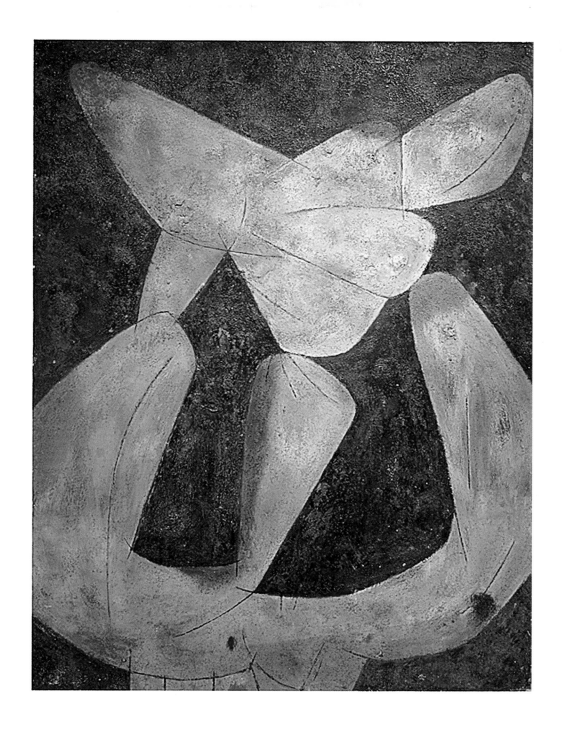

Artwork by Writers

Beginner's Mind – which preaches against duality of mind – it will be good *never* to lose, no matter how good you get. So for a writer, already willing to fail on the way to getting better, to try drawing might be to clear a few things out of your room, as Suzuki puts it. Useful in truth every day in one's long practiced vocation.

Yet isn't the clutter fertile too? What will a novelist without the end in sight turn to on a bad day for respite from life and syntaxes and history? Need we dissolve a divided, precariously detailed mind (to give Emptiness a chance)? As this walk through a gallery schools me, I stumble on the half-thought that writing is often *more* visual than painting. For the reader so readily collaborates: for, even if only ink on the page, don't words still with a speed of light enter us and provoke images that last a lifetime?

In theory freer, abstraction in this show may remind us of the writer's strange physical images for psychological insights (Henri Michaux), morphogenetic masks of what he wouldn't or couldn't try for in fiction (Jonathan Lethem), or skillfully marking off a material difference from what words want to express (Weldon Kees). By contrast, Marjorie Welish's acrylic on paper frames and unframes its yellow to bring differences so near as to recount what is connected beyond closeness, exchanging with her poems, particularly "In the Name of Studio," which distinguishes at least two ways of looking at a yellow, to free seeing and thinking into an open act of contemplation, private and public, it occurs to me.

Charles Simic's words, often about what is about to vanish with departure or passing attention, spring on us thing and metaphor, make us be briefly in it in the middle of nowhere, while he is animating what is not animate or not concrete though all the more alive for the moment. His oils, on the other hand, do that for us or without us, small as they are (and I think must be), with a rich brush or palette knife – whatever he used – an abstract act with a body of motion – that carry along with his trademark suddenness and surprise that potential vanishing from attention or even consciousness that we know is on his mind. In the painting of the hurled breaking sun above a bridge, the white bar reminds me of the painter's still hand, happy to be laying on the paint even instead of words. The other painting, the yellow one, reminds me of somewhere in a poem of his "headlines going up in flames" – while here the off-white rising, rising at the bottom asks of the rest of the action where does all this untitled stuff think it's coming from?

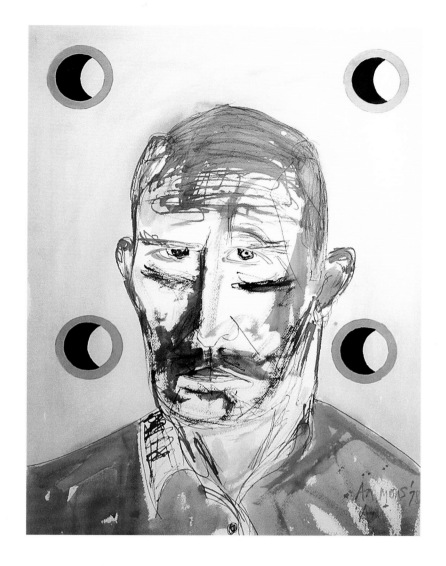

Fine fracture lines of the egg breaking in A.R. Ammons' painting of bird birth take me back into science's palimpsest of the art of nature. Embryonic growth mysteriously reciprocal between cells and the active field where they develop: as I have come to think when I weigh our psychic lives and their occult leaps into what is seen later to have been partly known. The layered impress of transition in Ammons' painting gathers itself into my verbatim memory of the shore scene in his great free verse Nature poem, "Corson's Inlet," where demarcation lines are blurred yet exactly experienced and imagined by words all the more spontaneous for long thought and walking and looking.

above:
A.R. Ammons
Untitled Portrait, 1977
Watercolor on paper
24" x 18"
Courtesy of Emily Herring Wilson

Artwork by Writers

The Writer's Brush Exhibition at
Pierre Menard Gallery Cambridge, MA
5 December 2007 – 20 January 2008

The Artists

WALTER **ABISH** (1933–) was born to prosperous, assimilated Jewish parents in Vienna, which his family fled, first to Italy and then to China, where they lived in Shanghai from 1940 to 1949, before emigrating to Israel, where Abish served in the army. He moved to the United States in 1957, becoming a citizen in 1960. Although now well known for his elusive, captivating fiction, his first book was a collection of poems published by Tibor de Nagy Editions in 1970, *Duel Site*. The title refers to the location of the fatal duel between Aaron Burr and Alexander Hamilton near where Abish then lived, but is also a punning allusion to the "dual sight" from which Abish suffers and for which he wears an eye patch. He published *Double Vision: A Self-Portrait* in 2004.

this page:
Walter Abish
Lumumba Trilogy, 1961
Watercolor on paper
each 18" x 25"
Courtesy of the Artist

The Writer's Brush

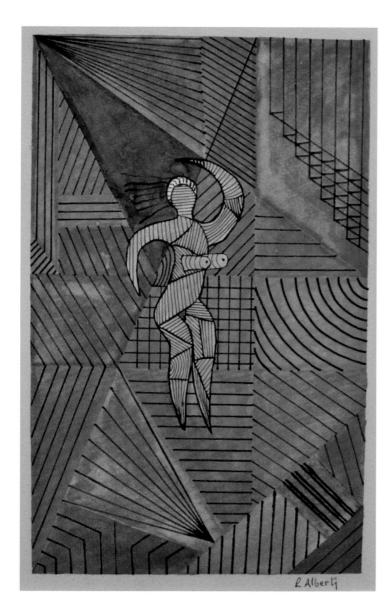

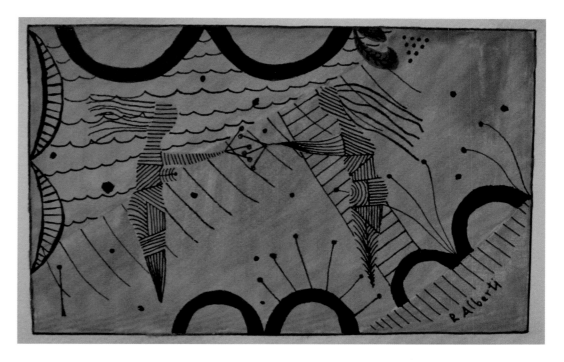

RAFAEL **ALBERTI** (1902-1999) was born in Puerto de Santa Maria, Cadiz, and educated at the Jesuit academy in Madrid. A dramatist and one of the defining poets of the "Generation of 1927," he served on the Republican side in the civil war and subsequently went into exile in Buenos Aires, returning to Spain only in 1977. His greatest poetry combines an exquisite baroque formality with the earthy folkloric elements that pervade the Spanish sensibility, both commingling at times with the surreal. Alberti worked all his life in a variety of media, including tempera and watercolor, engraving and collage, and illustrated his own books and those of others.

left:
Rafael Alberti
Untitled, 1965
Watercolor on paper
10 ½" x 6 ½"

above:
Rafael Alberti
Untitled, 1965
Watercolor on paper
6 ½" x 10 ½"

ROBERTA **ALLEN** (1945–) was born in New York, NY. She has written a total of five novels and story collections as well as a number of practical works on writing and self-expression, in which she offers workshops and private instruction. She was a presence in the avant-garde art-world of the sixties and seventies, and after a rather long hiatus from the art scene, she has again begun to exhibit work in public. Public collections in which her work is held include The Metropolitan Museum of Art and Bibliotheque du France.

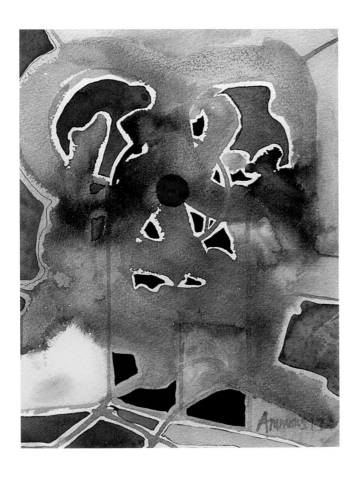

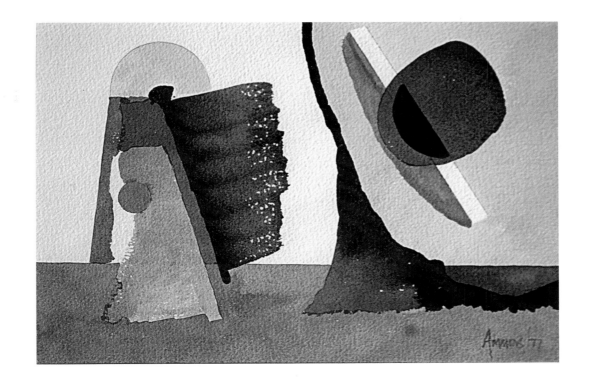

A. R. **AMMONS** (1926-2001) was born in North Carolina and attended Wake Forest College and the University of California, Berkeley. For almost a decade he worked as a sales executive at his father-in-law's glass company, Friedrich & Dimmock, Inc. in Millville, New Jersey. Beginning with his first book, *Ommateum, with Doxology*, issued by a vanity press, he gradually grew into a major poet in the American transcendental tradition exemplified by Emerson and Thoreau, and was awarded the Bollingen Prize for Poetry for 1973-1974. Exhibitions of his art have been held at Wake Forest and Cornell University.

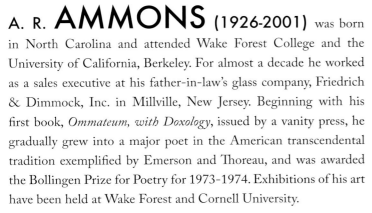

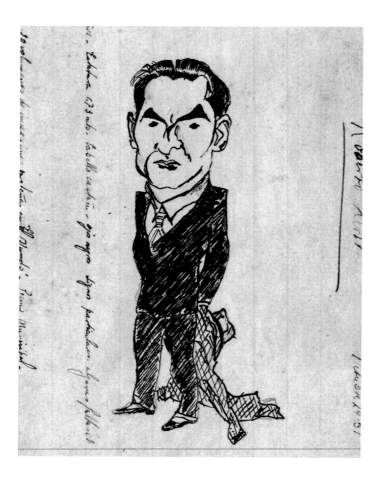

to florene and dick
l. arp

ROBERTO ARLT (1900–1942) novelist, short story writer, and playwright, and a major influence on Latin American literature, was born in Buenos Aires, the only son of immigrant parents, his father Prussian, his mother from Trieste and Italian-speaking, and his first language was German, not Spanish. Expelled from school in the third grade, he never returned. After working at various menial jobs he became a newspaperman, ultimately with a popular, acerbic column. His early death of a stroke was attributed to hard living. Two of his novels became Argentinian films: *Los siete locos* (1974) and *El juguete rabioso* (1985).

JEAN (HANS) ARP (1887–1966) was born in Strassbourg, and grew up equally at home in French and German. Although he studied painting at the Strassbourg Academy, the Academy of Fine Arts in Weimar, and the Academie Julian in Paris, he always characterized himself as a "poet," whether working in language or otherwise. He is associated in one way or another with virtually every avant-garde movement of the first half of the 20th century, and is considered one of the founders of Dada.

JOHN **ASHBERY** (1927–) the author of more than twenty major collections of poetry, from *Some Trees*, as well as various plays and prose works was born in Sodus, New York in 1927, graduated from Harvard College and took his M. A. in English from Columbia, before enrolling in French at NYU. The last surviving member of the so-called New York School, his *Self-Portrait in a Convex Mirror* won the National Book Award, The National Book Critics Circle Award, and the Pulitzer Prize in 1975, and he has since garnered many honors including a MacArthur Fellowship. For several decades he earned his living principally as an art critic, writing for such publications as the *International Herald Tribune*, *Art News*, and, later, *Newsweek*. His friendship with artist Fairfield Porter influenced Ashbery's painting. In fact, the interior scene depicted here was created, per Ashbery's report, under Porter's direct guidance. An exhibition of his surrealist collages was mounted at Tibor de Nagy in 2008.

above:
John Ashbery
Untitled, 1957
Watercolor on paper
22" x 25"

next page:
John Ashbery
Three Collages, 1970
Collage on paper
each image 4" x 6"

All courtesy of the Artist

H-1438 EL ORTIZ, SANTA FE INN, LAMY, NEW MEXICO.

ENID BAGNOLD (1889-1981) is best remembered as the author of *National Velvet* (1935), which was made into a movie starring Elizabeth Taylor in 1944. She was born in Kent but raised in the West Indies. Returning to London as a young woman, she worked for a time for the amorist lover and memoirist, Frank Harris. Bagnold studied art under the noted impressionist and modernist Walter Sickert.

right:
Enid Bagnold
Untitled, 1915
Etching
10 ¼″ x 7 ¼″

left:
Enid Bagnold
Untitled, 1913
Charcoal on paper
13 ¼″ x 8 ¼″

Both courtesy of Victoria McManus

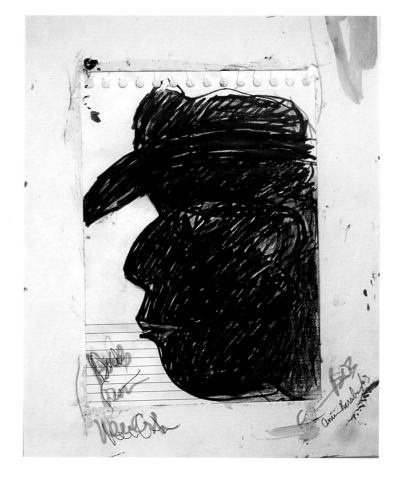

left:
Amiri Baraka
Stealing (The Election)
Watercolor and pastel on paper
14 x 10 ½"

right:
Amiri Baraka
Dude from Newark
Pastel on paper
14 x 10 ½"

Both courtesy of the Artist

AMIRI **BARAKA** (1934–) the controversial black nationalist author of plays, poems, novels, stories, essays, and tracts, was born LeRoi Jones in Newark, New Jersey, attended Rutgers, Howard, and Columbia Universities, before publishing his first book of poetry, *Preface to a Twenty Volume Suicide Note* in 1961. He started to draw in childhood, and has been actively painting and exhibiting his work through adulthood.

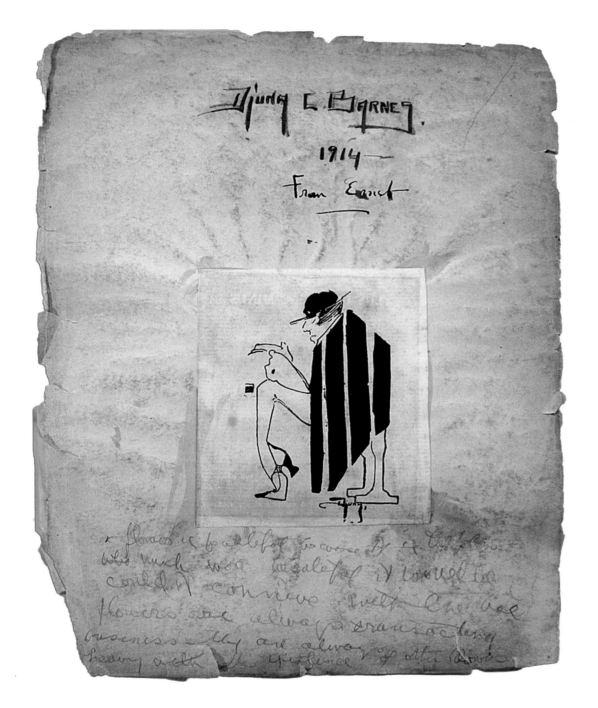

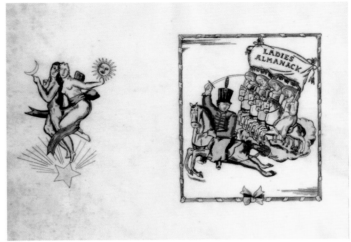

DJUNA **BARNES** (1892–1982), although

long resident in Europe, was born in Cornwall-on-Hudson, New York, and attended the Pratt Institute and the Art Students League in Manhattan. Afflicted with severe alcoholism and mental distress, she required repeated hospitalization. Her finest work – the novel Nightwood (1936) and her verse play The Antiphon (1958) rank with that of her greatest modernist contemporaries. She was an excellent draughtsman, and her writings were often accompanied by her own illustrations.

left:
Djuna Barnes
Frau Ernst, 1914
Ink and mixed media on paper
11 ½" x 9"
Courtesy of Peter Harrington, Bookseller

above:
Djuna Barnes
Ladies Almanack, 1928
Handcolored lithograph on Rives
approx. 9" x 18"
Private Collection

MARY **BEACH** **(1919–2006)** was born in Hartford, CT and spent six months a year in France during her youth. In 1941 she was sent to the Nazi prison camp, Glacière, for a short time. Against the protests of her family, but encouraged by her distant relative, Sylvia Beach of Shakespeare & Co., she became an artist and mounted her first solo show at the Galerie du Béarn, in Pau, France in 1943. She met Claude Pélieu in 1962 and together they began working and exhibiting all over the world. Though she is most famous for her collage work, she was also was an accomplished painter and draughtswoman, as well as a writer, translator, editor, and publisher, first for City Lights Books and later for her own imprint – Beach Books, Texts & Documents – where she collaborated with and published Pélieu, William Burroughs, Allen Ginsberg, and Bob Kaufman among many others.

JULIAN **BECK** **(1925–1985)** founder, with his wife Judith Malina, of The Living Theater, was born in Manhattan and briefly attended Yale. He started his creative life as an abstract expressionist painter, but after 1948 he devoted his life to drama, frequently political, designed to shock the audience out of its complaisance. The result was arrests on several continents and being shut down in the U.S. by the IRS. In addition to plays, he wrote several volumes of poetry espousing his anarchism, and two highly regarded books about the theatre. Through all the vicissitudes of his life, he continued to paint and draw, and his work as a stage designer drew amply on his painterly and sculptural gifts.

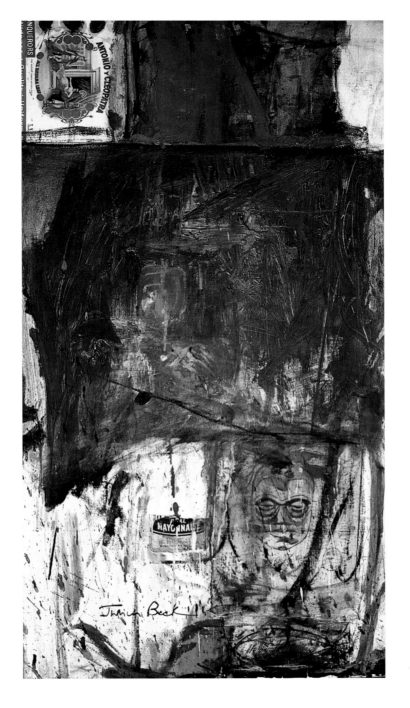

left:
Julian Beck
Romeo and Juliette, 1957
Mixed media on canvas
40" x 22"

Courtesy of Janos Gat Gallery

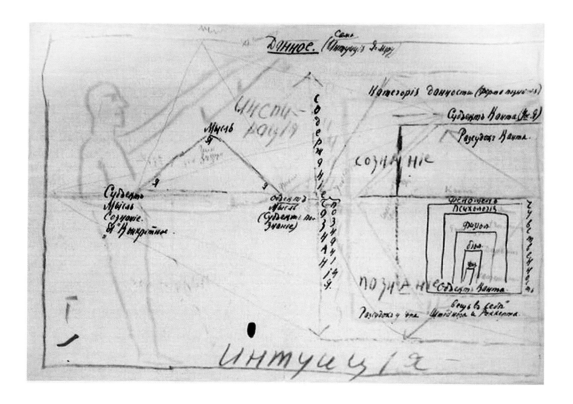

ANDREI **BELY** (1880–1934) was born Boris Nikolayevich Bugayev, the only child of N.V. Bugayev, dean of the faculty of Natural Sciences and the University of Moscow, and one of Russia's most distinguished mathematicians. Bely was a poet as well as one of the original, and perhaps the greatest, prose stylist of the Russian symbolist movement. Besides many critical and philosophical works, he is remembered for his four-volume memoir that paints an intricate, often satirical portrait of Russian intellectual life over a span of 25 years, and for his novel *Petersberg* which no less a reader than Vladimir Nabokov named the third greatest work of Twentieth Century literature after *Ulysses* and Kafka's *Metamorphosis*. A Steinerian, many of his manuscripts bear evidence of the master's mystical teachings, including multicolored illumination in accordance with Steinerian schema.

BILL **BERKSON** (1939-) was born in New York City in 1939 and attended Brown, Columbia, The New School, and NYU's Institute of Fine Arts. Among his many volumes of poetry are *Serenade* and *Fugue State*. He also published a prose collection *The Sweet Singer of Modernism and Other Art Writings*, 1985-2003). At present he is associated with the San Francisco Art Institute.

TED **BERRIGAN** (1934–1983)

was born in Providence, Rhode Island, and eventually graduated from the University of Oklahoma at Tulsa, where he was a leader of what has been called the "Tulsa Renaissance," one assumes ironically. He soon relocated to New York where he became, along with Ron Padgett and Anne Waldman, a principal figure in the so-called "Second Generation of the New York School." His first book, *The Sonnets*, warmly praised by Frank O'Hara, is in many respects his most interesting. Thereafter he often worked in collaboration, eschewing the notion of a poet's sole "ownership" of a poem. His complete poems, both published and unpublished, were issued as *The Poetry of Ted Berrigan* in 2005.

Above:
Ted Berrigan & George Schneeman
Untitled, c. 1967
Mixed media collage on paper
12" x 12"
Private Collection

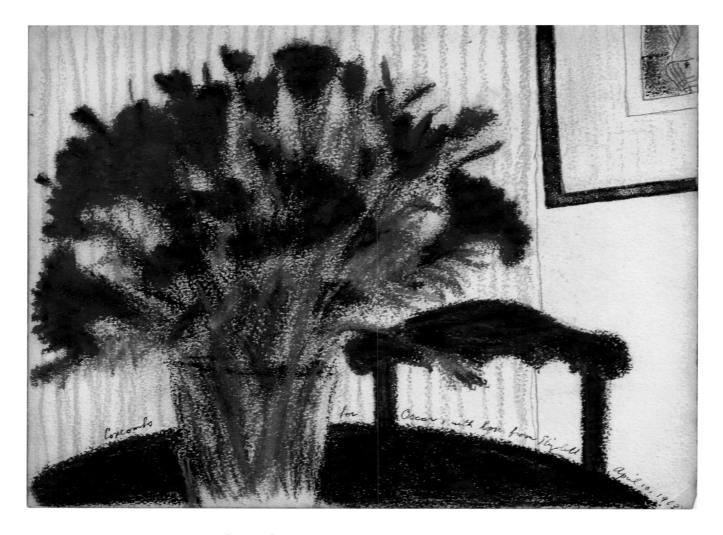

ELIZABETH **BISHOP** (1911–1979) Pulitzer Prize-winning poet, was born in Worcester, Massachusetts, graduated from Vassar, and lived with her lover, Lota de Macedo in Brazil for seventeen years. Although her total output was relatively small, it is almost uniformly excellent in quality, from her first volume *North & South*(1946) to her last *Geography III* (1976). She painted, mainly in watercolor and gouache, in a vaguely primitive style of closely observed detail.

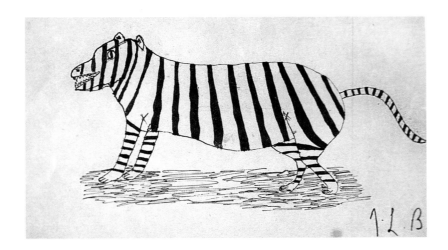

JORGE LUIS **BORGES** (1899-1986) was born in Buenos

Aires. A foppish litterateur well into middle-age, with the publication of *Ficciones* (1945) – called by some the most influential Spanish language book of the 20th century – he was bewilderingly transformed into a giant of late Modernism, an event which seemed to surprise even himself, although he was by no means ever genuinely sincere in his numerous declarations of humility.

NORAH **BORGES** (1901–1998) was born in Buenos

Aires and moved with her family, including brother Jorge Luis, to Switzerland, where she studied at la École des Beaux-Arts, Geneva. She wrote and published her first book of poetry, *Notas lejanas* in Switzerland in 1915. She traveled widely in Europe, publishing poetry and absorbing most of the vanguard currents of the era, including expressionism, dadaism, surrealism, and ultraism. Returning to Buenos Aires she joined the avant-garde Florida Group and continued to work in oils, woodcarvings, drawings, watercolors, and tapestries until her death. In addition to her poetry, she wrote art criticism under the pseudonym Manuel Pinedo. Not caring for art exhibitions, she participated rarely, choosing either to gift her work or use it to illustrate magazines and books by Jorge Luis Borges, Adolfo Bioy Casares, Victoria and Silvina Ocampo, Julio Cortázar, Rafael Alberti, Juan Ramón Jiménez, and others.

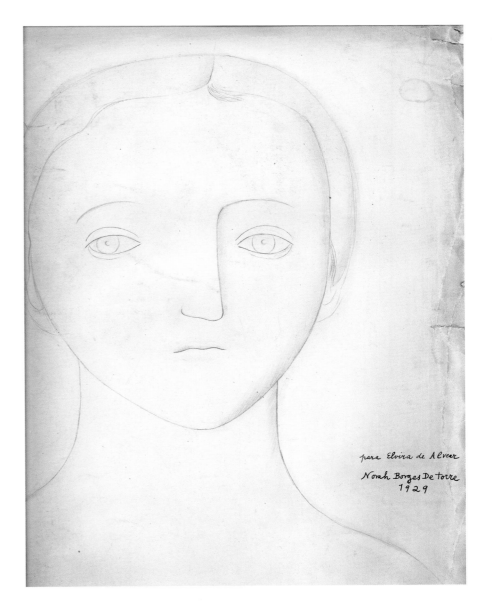

left:
Jorge Luis Borges
Untitled (Tiger), c. 1920
Ink on paper
5 ½ " x 8"
Private Collection

above:
Norah Borges
Portrait of a Woman, 1929
Ink on paper
12 ½" x 10"

BREYTEN **BREYTENBACH** (1939–)

was born on the Western Cape of South Africa and studied fine arts at the University of Cape Town. He moved to Paris in the 1960s and married a Frenchwoman of Vietnamese descent. This put him in violation of South African apartheid law. Active in anti-apartheid resistance, Breytenbach returned to his homeland clandestinely in 1975, was betrayed, and convicted of high treason. After serving seven years in prison, he returned to France and became a citizen. He writes verse and prose, in Afrikans and English, and often translates his works from one to the other. His best known book *The True Confessions of an Albino Terrorist* draws on his prison experiences. His paintings are exhibited in Europe, Africa, Asia, and the United States.

right:
Breyten Breytenbach
***The Artist and His Models**, 1998
Etching
22" x 15"
Courtesy of the Artist

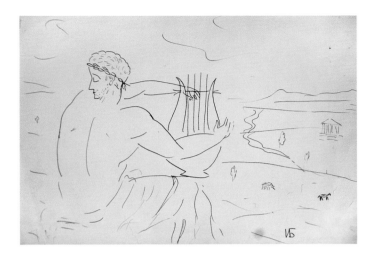

JOSEPH **BRODSKY** (1940–1996)

winner of the 1987 Nobel Prize in Literature, the 1991 Poet Laureate of the United States, and a member of the American Academy and Institute of Arts and Letters. He was born in Leningrad, Russia, where he grew up in poverty in communal homes, his family marginalized as Jews. He was eventually expelled from the Soviet Union in 1977 for "social parasitism," but not until his poetry had been denounced as anti-Soviet, his papers confiscated, he'd been confined to a mental institution, and arrested and sentenced after a secret trial to five years hard labor.

above:
Joseph Brodsky
Orpheus, 1963
Ink on paper
11 ¾" x 16"
Private Collection

right:
Joseph Brodsky
Portrait of Michael Beleminsky, 1959
Charcoal on paper
12 ¾" x 9 ½"
Private Collection

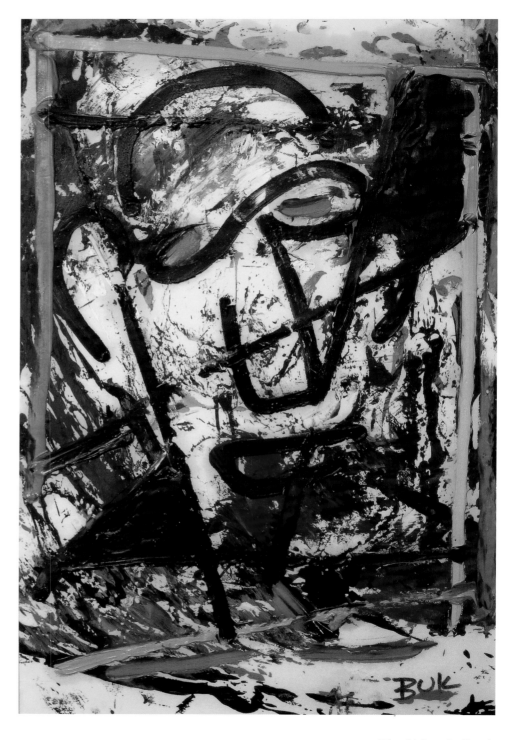

CHARLES **BUKOWSKI** (1920–1994)

was born in Germany, the son of an American GI and a German woman, and raised in the United States, where he became a skid-row alcoholic; then in his 30's began to write and produced some 60 books of verse and prose. He is noted especially for the series of semi-autobiographical novels chronicling the alcoholic misadventures of his alter-ego Henry Chinaski, beginning with *Post Office* (1972) and ending with *Ham on Rye* (1982). Bukowski was also prolific as a painter, and was encouraged by John Martin, his publisher at Black Sparrow books, to do original illustrations inside the covers of his many books.

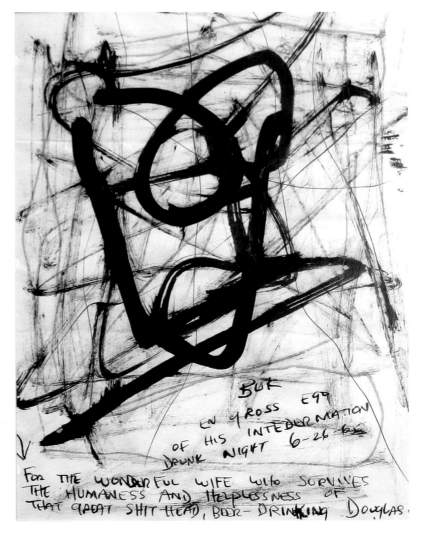

opposite:
Charles Bukowski
Untitled, c. 1968
Oil on paper
9" x 6"

above left:
Charles Bukowski
Untitled, c. 1970
Ink and pastel on paper
13 ¾" x 10 ¾"

above right:
Charles Bukowski
Douglas, 1965
Ink and mixed media on paper
10 ½" x 8"

All Courtesy of Nick Lawrence

GELETT **BURGESS** (1866–1951) M.I.T. graduate,
author and artist, founder and editor of the San Francisco based humor magazine, *The Lark*, whose first volume contained the eight line nonsense poem "Purple Cow" which Burgess would spend his life trying to eclipse. He is remembered today mainly for his light-hearted books, such as *Goops and How to Know Them*, and *Are You a Bromide*? which he illustrated with light-hearted drawings.

above:
Gelett Burgess
***To Flo [] A Merry X-mas**, 1902*
Watercolor on board
3 ½" x 6"
Courtesy of Justin G. Schiller

The Writer's Brush

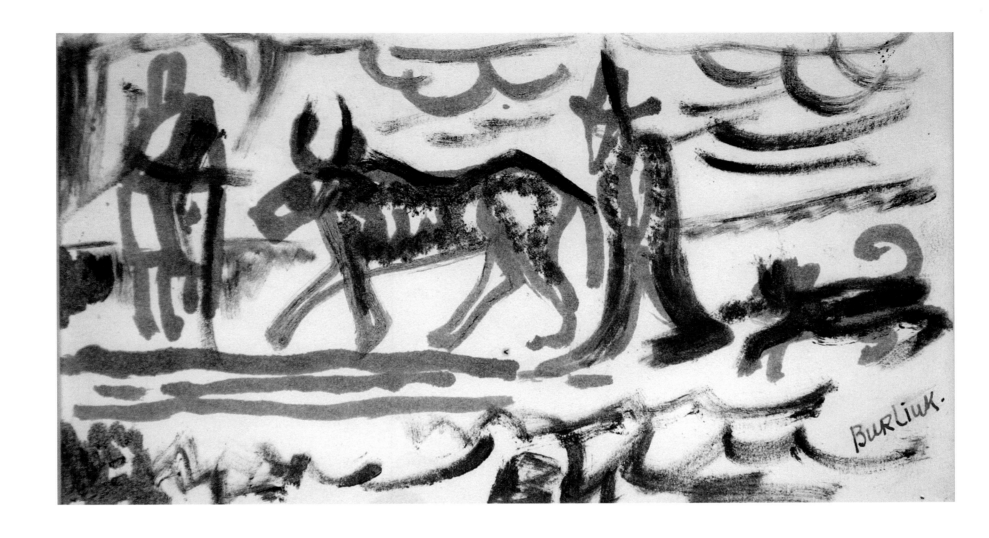

DAVID **BURLIUK** (1882–1967) was born in Ukraine and attended art school in Odessa, and later in Munich and St. Petersburg. He illustrated and designed many futurist books, and was the co-author of the famous futurist manifesto *A Slap in the Face of Public Taste*.

above:
David Burliuk
Untitled, c. 1930
Watercolor on paper
5 ¾" x 10 ¼"

WILLIAM S. **BURROUGHS** (1914-1997)

a drug addict for most of his adult life, and one of the principal figures of the Beat movement was born in St Louis, and attended Harvard University as the child of a privileged family. His most famous book was *Naked Lunch*, a first use of a so-called "non-linear" style, written in Tangiers and edited with the help of Jack Kerouac and Allen Ginsburg. He experimented with various visual media throughout his life, including action painting and film. Burroughs was elected to the American Academy and Institute of Arts and Letters in 1984, and was made a *Commendeur de L'Ordre des Arts et Lettres* by the French Government in 1985.

The Writer's Brush

JOSEF ČAPEK (1887–1945) the older brother of Karel Čapek, with whom he collaborated on sketches and stories, and without whom he wrote plays and short novels and art criticism, studied painting in Prague and Paris, and worked as a cartoonist with the Prague newspaper *Lidove Noviny*. A Jew, he was seized by the Germans after their 1939 invasion and died in Bergen-Belsen in April, 1945.

opposite right:
William Burroughs
Untitled, 1965
Mixed Media on paper
23" x 17 ½"
Courtesy of Ken Lopez, Bookseller

opposite left:
William Burroughs
Avarice, 1965
Screenprint from an edition of 90
45" x 31"
Courtesy of Lococo Fine Art

above:
Josef Čapek
Untitled, 1920
Linocut
25" x 19"
Courtesy of Michael Fagan

R.V. **CASSILL** (1919–2002) was born in Cedar Falls, Iowa, received a BA and MA at the University of Iowa, and studied at the Art Institute of Chicago as well as the Sorbonne. He taught at Columbia, the New School, the University of Iowa Writer's Workshop, Purdue, Harvard and Brown. As a life-long painter and lithographer he began exhibiting in Chicago in 1946, and as a writer he published twenty-four novels and seven collections of short stories, ranging over vast swaths of contemporary American topicality in lucid, quite visual, prose.

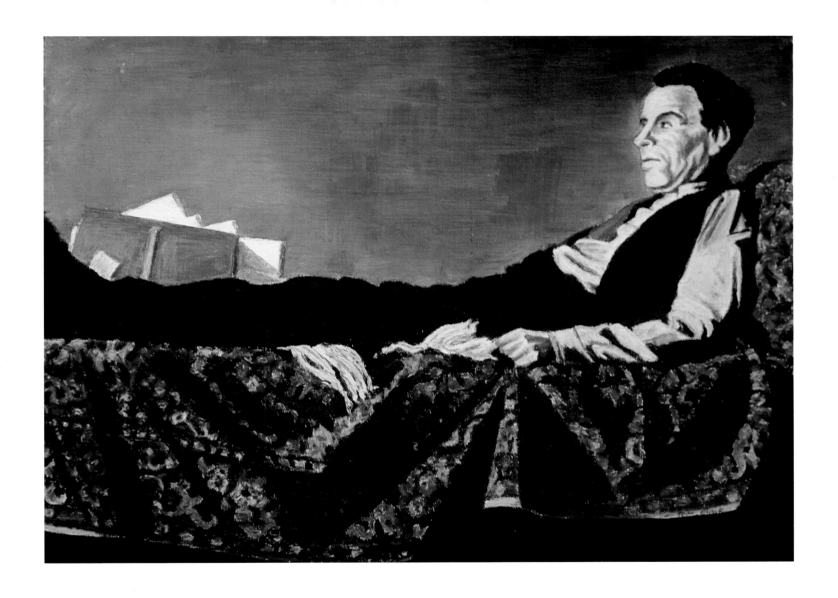

TOM CLARK (1942–) a poet, and poetry editor of the Paris Review from 1963 to 1973, was born in Chicago in 1941 and attended the University of Michigan, Cambridge University, and the University of Essex. In addition to his poetry, Clark is also well known for his studies and biographies of Kerouac, Olson, Creeley, and Dorn.

above:
Tom Clark
Portrait of Celine, c. 1980s
Acrylic on board
11 ½" x 15 ½"
Courtesy of the Artist

above:

Daniel Clowes

From *David Boring,* c. 2002

Ink on paper

20" x 14"

Courtesy of the Artist

DANIEL **CLOWES** (1961–) was born in Chicago and attended Pratt Institute in New York. He is a leading graphic novelist, his work often focusing on the tribulations of forlorn characters. Two of his books, *Ghost World* and *Art School Confidential* were made into movies by Terry Zwigoff, with screenplays by Clowes.

The Writer's Brush

JEAN **COCTEAU** (1889–1963) was a poet,

playwright, novelist, filmmaker, essayist, artist, and sculptor, Cocteau demanded that his only title be "poet" – that his works should be described as poésie de théâtre, poésie cinematographique, poésie critique, poésie graphique, and poésie plastique. Among his notable achievements are the poem "L'Ange Heurtebise" (1925), the novel *Les Enfants terribles* (1929), the play *La Machine infernale* (1934), and the films he wrote and directed *La Belle et la bête* (Beauty and the Beast) (1946) and *Orphée* (1950). He was elected to the *Academie francaise* in 1955.

above left:
Jean Cocteau
Untitled, 1960
Pastel on paper
12 ½" x 10 ½"
Private Collection

above:
Jean Cocteau
Abstract Head, 1961
Marker on paper
16 ½" x 12"
Private Collection

NORMA **COLE** (1945–) is a Canadian-American poet, visual artist and translator. She received both her BA and MA at the University of Toronto, and currently lives in San Francisco. Her work is usually associated with the Language poets, and is allied with strains of contemporary French poetry. She has published seventeen books of poetry, three experimental text/image works, and nine translations, and has won numerous awards. She was the head artist in *Collective Memory*, an evolving installation, performance, and publication between 2004-2006.

above:
Norma Cole
Untitled, c. 2006
Watercolor on paper
12″ x 15″

belowt:
Norma Cole
Untitled, c. 2006
Watercolor on paper
12″ x 15″

Both courtesy of the Artist

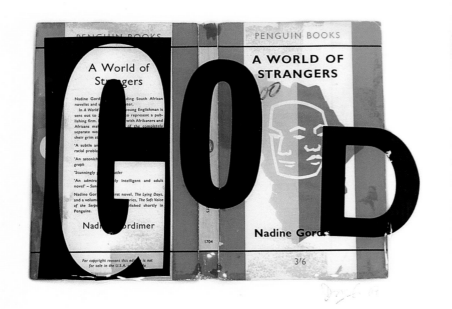

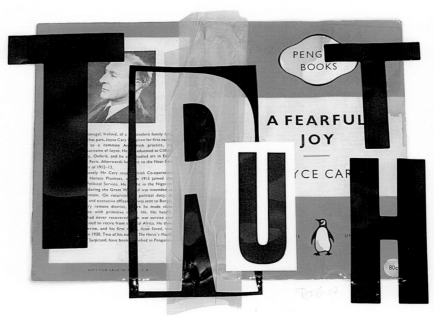

DOUGLAS COUPLAND (1961-) the voice of Generation X – a term he coined – upon publication of his first novel, *Generation X: Tales for an Accelerated Culture* (1991), writes plays, essays, and short stories, and is an artist, sculptor, and industrial designer. He attended the Emily Carr College of Art and Design, Vancouver, the Hokkaido College of Art and Design in Sapporo, Japan, and the Instituto Europeo di Design, Milan.

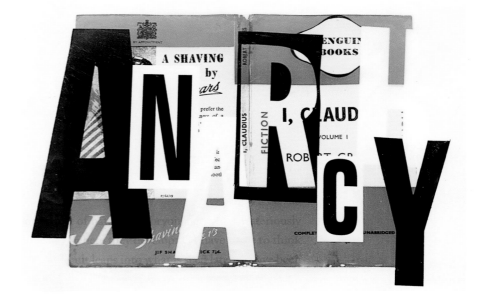

above:
Douglas Coupland
God, 2007
Mixed Media on Canvas
9" x 12"

above right:
Douglas Coupland
Truth, 2007
Mixed Media on Canvas
9" x 12"

below right:
Douglas Coupland
Anarchy, 2007
Mixed Media on Canvas
9" x 12"

All courtesy of the Artist

MORRIS COX (1903–1998) was the founder and proprietor of the Gogmagog Press, which was celebrated in a monograph published by the Private Library Association in 1991. Throughout a long life, Cox made many paintings, drawings, prints, photographs, and sculptures, all the while writing distinctive poetry and prose. However, only one volume of poetry was ever issued by a commercial publisher – *The Whirligigand and Other Poems* from Routledge and Kegan Paul in1954. Also designed by Cox, it is now a highly prized rarity. His bibliographer, antiquarian bookseller Colin Franklin, has called Cox "the Blake of my time."

above:
Morris Cox
Untitled Figure, 1977
Ink on paper
11 ½" x 9"
Courtesy of the Artist

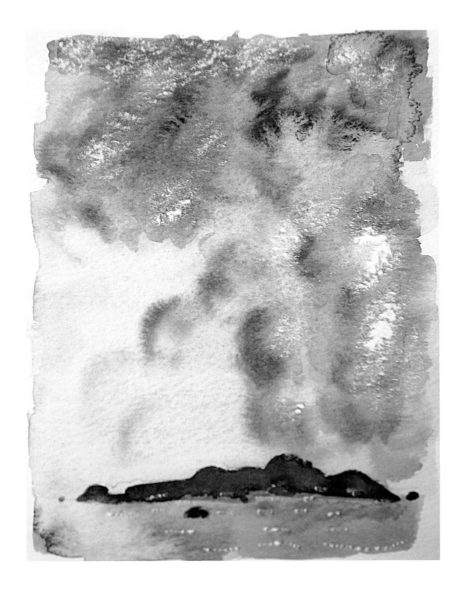

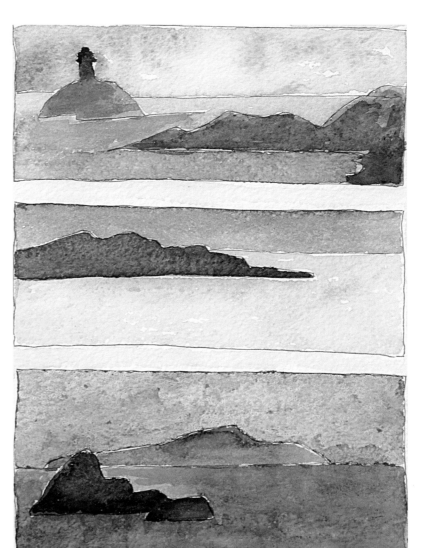

JIM **CRACE** (1946–) was born in Hertfordshire, England in 1946, and graduated from London University in 1968. He worked as a journalist and wrote a number of short stories and radio plays, before winning the Whitbread First Novel Award in 1986 for *Continent*. A number of other highly-regarded novels have followed.

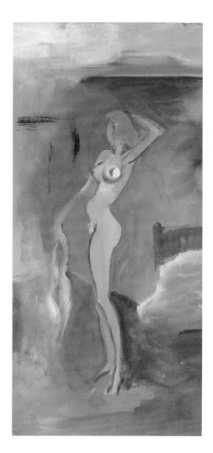

above:

e.e. cummings
Street Scene, 1962
Oil on canvas
16" x 12"

above center:

e.e. cummings
Standing Nude, c. 1940
Watercolor on shirtboard
17 ½" x 8 ½"

above right:

e.e. cummings
Portrait, c. 1950
Watercolor on shirtboard
17 ½" x 8 ½"

e. e. **cummings** (1894–1962) was born in Cambridge, Massachusetts and earned a B.A. and M.A. from Harvard before joining the American volunteer Norton Harjes's Ambulance Corps during World War I. He became a very famous poet, his typographical experiments catching the popular imagination. Before his death he garnered among other literary honors, the Shelley Memorial Award (1945), the Academy of American Poets Fellowship (1950), the National Book Award for *Poems 1923-1954,* and the Bollingen Prize in 1958. He worked all his life as a visual artist in various styles and media and always regarded himself equally as a poet and a painter.

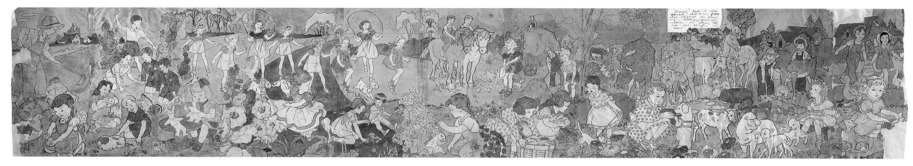

HENRY **DARGER** (1892–1973) one of the oddest of so-called "outsider artists," was born in Chicago. His mother having died when he was four and his father incapacitated by illness, Darger was placed first in a Catholic orphanage, and later, when he was declared "simple minded" in a mental institution from which he repeatedly tried to escape. Eventually released, he made his way to Chicago and took a job as a janitor in a Catholic hospital, and attended mass as often as five times a day. His artistic life was entirely solitary, and known to no one. A few days before his death, the landlord of his Chicago rooming house discovered Darger's 15,145-page fantasy manuscript called *The Story of the Vivian Girls, in What is known as the Realms of the Unreal, of the Glandeco-Angelinnian War Storm, Caused by the Child Slave Rebellion*, along with several hundred drawings and watercolor paintings illustrating the story, and recognized their merit. Darger became posthumously famous.

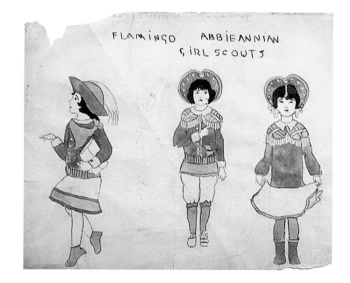

FERNANDO **DEL PASO** (1935–), was born in Mexico City. A poet essayist, and novelist, he lived in London for fourteen years where he worked for the BBC. He has since won many of the most important literary awards in the Spanish-speaking world for his work, which includes the acclaimed great masterpiece invariably denominated Rabelesian or Joycean, *Palinuro de Mexicoa.* A major practitioner of the new historical novel, his work has profoundly influenced the younger generation of Mexican writers known as Generation Crack.

above left:
Fernando Del Paso
Untitled, c. 1990
Ink on paper

above center:
Fernando Del Paso
Homage to Octavio, c. 1990
collage on paper

above left:
Fernando Del Paso
Untitled, 1990
Acrylic on paper

All courtesy of the Artist

above:
Annie Dillard
Self Portrait, c. 1975
Acrylic on canvas
14" x 11"
All courtesy of the Artist

right:
Annie Dillard
Untitled, c. 1975
Acrylic on canvas
12" x 9"

opposite:
Annie Dillard
Untitled, c. 1975
Acrylic pastel on board
5" x 7"

ANNIE **DILLARD** (1945–) winner of the Pulitzer Prize in 1974 for *Pilgrim at Tinker Creek*, is a novelist, poet, essayist, literary critic, and memoirist. Born in Pittsburgh, she graduated from Hollins College, in Roanoke, Virginia. . Her work is a spiritual, though distinctly non-sectarian, and not necessarily even religious engagement with nature and human experience. She is certainly among the most idiosyncratic thinkers and stylists in contemporary American letters. The artist Jenny Holzer used the entire text of her wonderful autobiography *An American Childhood* as the basis for a public installation at the Carnegie Museum in Pittsburgh. Proceeds from the sale of her own often quite striking artwork have been contributed to Dr. Paul Farmer's Partners in Health Foundation.

The Writer's Brush

J.P. DONLEAVY (1926–) was born in Brooklyn but

matriculated at Trinity College, Dublin after serving in the Second World War and has lived in Ireland most of the intervening decades. He turned to literature only after abandoning a career as a painter to which he returned in his later years. Donleavy had an immense popular success with *The Ginger Man*, published in Paris in 1955. An expurgated edition was issued two years later in the United States. He went on to write many further novels as well as various plays and stage adaptations as well as several highly amusing works on what might be called etiquette for the upwardly mobile.

JOHN **DOS PASSOS** (1896–1970)

was born in Chicago, the illegitimate son of a business lawyer who didn't acknowledge the boy until he was sixteen. A versatile writer with notable work as a dramatist, travel writer, translator, and historian, Dos Passos is primarily remembered as a novelist, whose *Manhattan Transfer* and the *U.S.A. Trilogy*, presented sprawling portraits of contemporary life with innovative narrative devices and techniques. He was elected to the American Academy of Arts and Letters in 1947. He painted and exhibited throughout his life and illustrated the dust jackets of several of his books.

RIKKI DUCORNET (1943–) is the author of many books of poetry and some seven novels, notably *The Fan Maker's Inquisition* and *The Jade Cabinet*, which was a finalist for the National Book Critic's Circle Award. In 1993 she received the Lannan Literary Award in Fiction. Her lithographs, drawings and paintings have been exhibited widely, appearing at the Museo de Bellas Artes, Mexico City, Museau National de Cestro Coimbra, Portugal, the Fine Arts museums of West Berlin, Ixelles, Brno, and Lille, and in the Biblioteque Nationale. She has illustrated books by Robert Coover and Jorge Luis Borges.

left:
Rikki Ducornet
Paper Doll, 2007
Gouache, acrylic, and watercolor on Arches heavy watercolor paper
22" x 30"
Courtesy of the Artist

The Writer's Brush

ROBERT **DUNCAN** (1919–1988) was
born in Oakland California, his mother dying in childbirth. He
was put up for adoption, and was raised by a couple of devout
theosophists who imbued him with the occult sensibilities that
pervade his work; this, along with the romanticism then very much
out of fashion, sharply differentiated him from the many avant-
garde movements with which he became associated, most of whose
enthusiasts were devoutly secular. He became in time a pillar of the
San Francisco Renaissance. Although, due to a childhood accident,
he became cross-eyed, seeing double, he was always intensely drawn
to the visual arts, and lived from 1951 until his death with the artist
Jess Collins, who illustrated a number of his books.

right:
Robert Duncan
Untitled, n.d.
Crayon on paper
14 ¼" x 17 ½"

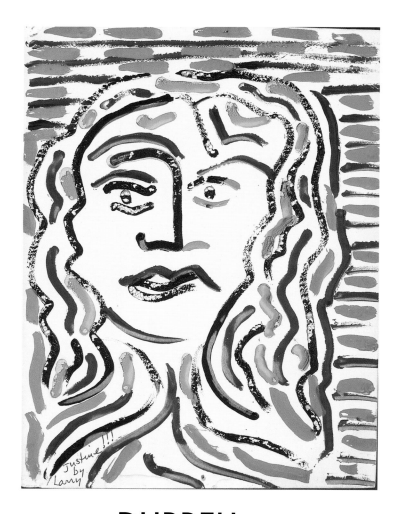

LAWRENCE **DURRELL** (1912–1990) was

born in India to British colonial parents and was sent to England for schooling at an early age. He served in the British diplomatic corps during the Second World War. His vast literary output was varied, and included essays, plays, poems, and travel books as well as novels. His most celebrated work, collectively known as *The Alexandria Quartet*, was published as four separate novels between 1957 and 1960. He and Henry Miller began painting while rooming together in Paris in the 1930's.

RUSSELL **EDSON** (1935–) poet, playwright, and novelist, frequently accompanies his writings with drawings and woodcuts that relate to and comment upon the text. "It's as if King Lear had been written and illustrated by Edward Lear," wrote Denise Levertov. Edson, who was born and continues to reside in Connecticut, began his career as a painter but claims to have abandoned it because he "found the whole thing just too messy."

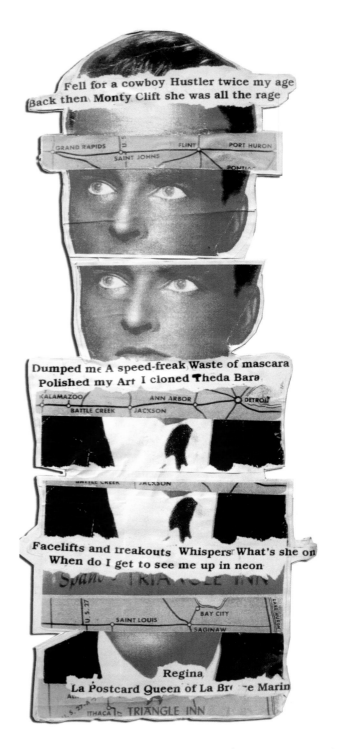

KENWARD **ELMSLIE** (1929–) was born in New York City. The grandson of Joseph Pulitzer and a graduate of the famous 1950 class of Harvard (along with Bly, O'Hara, Plimpton, Gorey, et al). Elmslie is a New York School poet, prose writer, playwright, performer, editor and publisher. His first book of poems, *Pavilions,* was published by the Tibor de Nagy Gallery in 1961, and he has worked extensively in the Theatre and in collaboration with visual artists, especially his quondam partner Joe Brainard. In 1973 he began *Z Magazine* and Z Press to publish the work of New York School artists.

The Writer's Brush

MARY **FABILLI** (1914–2011) was born in Gardiner, New Mexico, the daughter of immigrant Italian farmers. Known as a quiet voice of the Beat Generation, Fabilli has more than seven volumes of poems to her credit. She studied art at University of California, Berkeley where she met Robert Duncan who introduced her to the Beat scene. After a succession of difficult jobs she found a career teaching art and working as a curator at the Oakland Museum. She married Beat poet William Everson and illustrated some of his poems with linoleum block art. A devout Catholic whose religious feelings permeate her work, she encouraged her husband to Catholicism which resulted in his conversion, followed by his leaving her to join the Dominican Friars where he became known as Brother Antoninus.

left:
Mary Fabilli
Portrait of a Woman, c. 1955
Watercolor and ink on paper
9" x 12"
Private Collection

I STARTED OUT AS A VENTURE CAPITALIST.

MY COMPANY FAILED. I BECAME A BANK VICE PRESIDENT.

THE BANK FAILED. I BECAME A COLLEGE PROFESSOR, TEACHING A COURSE IN FREE MARKETS.

THE COLLEGE'S ENDOWMENT FAILED. I SOLD CARS.

DIST. UNIVERSAL PRESS SYNDICATE

©JULES FEIFFER 11-24

THE LOT FAILED. I MANAGED A PIZZERIA.

THE PIZZERIA BURNED DOWN. I PARKED CARS.

I WAS FIRED FOR SMASHING UP THE CARS I PARKED. PRESENTLY I'M SELLING PAPERBACKS ON THE STREET.

DOWNWARD MOBILITY—

THE NEXT AMERICAN DREAM.

JULES **FEIFFER** (1929–) whose plays have won a New York Drama Critics Award, a London Theatre Critics Award, Outer Circle Critics Awards, and two Obies, for *Little Murders* (1969) and *The White House Murder Case* (1970), was born in the Bronx. He is a novelist – *Harry, the Rat with Women* (1963), *Akroyd* (1977); screenwriter – *Carnal Knowledge* (1970), *Popeye* (1980); Academy Award-winning short filmmaker – *Munro* (1961); children's book author; and Pulitzer Prize-winning cartoonist whose strip appeared in the *Village Voice*, the *London Observer*, and *Playboy*.

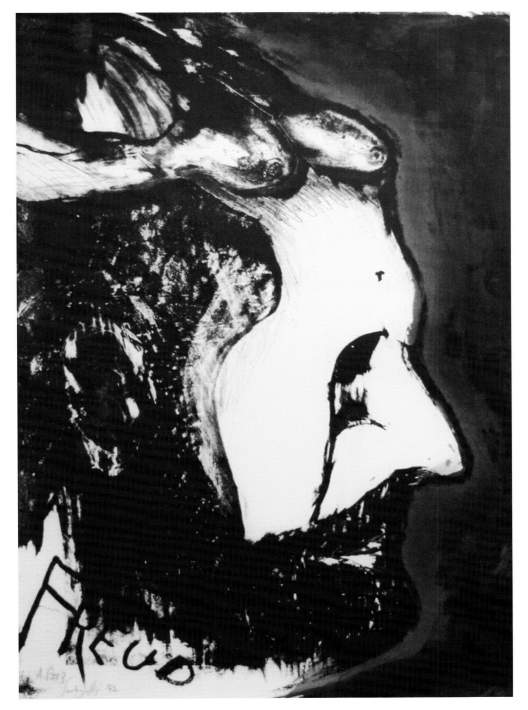

LAWRENCE **FERLINGHETTI** (1919–)

legendary Beat poet and playwright, and founder of San Francisco's City Lights Bookstore and City Lights Press, was born in Yonkers, New York. His father died before he was born and his mother institutionalized soon after. Taken to France by an aunt for five years, he was deposited in an orphanage on their return, but was soon placed with a family in Bronxville. He graduated from Chapel Hill and served as an officer in the Navy during World War II, then took an M.A. at Columbia and a doctorate from the Sorbonne. In Paris he also began to paint, and has continued ever since. His work has appeared in many group exhibitions and solo shows at galleries, museums, and universities, including the University of California at Santa Cruz (1990) and the Palazzo delle Esposizioni in Rome (1996).

JACOBO **FIJMAN** (1898–1970) was born in Orhei, Bessarabia and came to Argentina with his parents at the age of four. He was plagued by mental illness throughout his life, and already at the age of twenty-three he spent six months in a mental institution. Associated with the Ultraist group, Fijman published in the journal *Martín Fierro*, as well as three collections of poetry, and he was a friend of Girondo, Marechal, Macedonio Fernández, Xul Solar, and Borges. His work has been described as the "secret beginning" of surrealism in Argentina, and his self-effacing manner, in addition to its elegant metaphysical and spiritual elements, mark him as something of a literary saint. He spent his final twenty-eight years at the Borda Asylum, where he continued to write and to draw and paint actively, and a few quite interesting batches of further poems have surfaced over the years.

above center:
Jacobo Fijman
Untitled, c. 1950
Pastel on paper
8 ¾" x 6 ¾"

above right:
Jacobo Fijman
Untitled, c. 1950
Pastel on paper
8 ¾" x 6 ¾"
Private Collection

above:
Jacobo Fijman
Untitled, c. 1950
Pencil on paper
8 ¾" x 5 ¼"
Private Collection

CHARLES HENRI FORD (1908–2002) was born in Hazelhurst, Mississippi into what would now be termed a dysfunctional family, was expelled from various Catholic schools and, somehow, landed in New York City. Emulating Cocteau, he wrote poetry and various prose works, drew, made collages, took photographs, and a shot a film – *Johnny Minotaur*, staring Allen Ginsburg. He edited America's first surrealist magazine *View*, whose contributors included Breton, Ernst, Cornell, and Man Ray.

above right:
Charles Henri Ford
Untitled, c. 1995
Collage on paper
36" x 48"

above:
Charles Henri Ford
Untitled, c. 1995
Collage on paper
48" x 36"
Both estate of the Artist

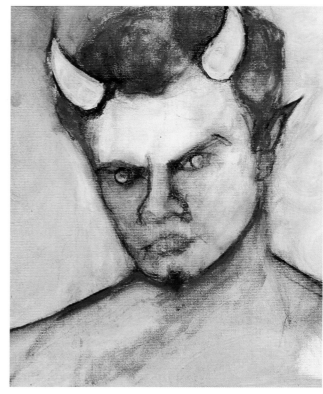

above:
Ciff Forshaw
Armed Centaur with Angel,
2000
Acrylic on canvasboard
9″ x 12″

above right:
Ciff Forshaw
Self-Portrait as Devil, 2000
Acrylic on canvasboard
12″ x 9″
Both courtesy of the Artist

CLIFF **FORSHAW** (1953–) was born in Liverpool, England, left school at sixteen and worked in an abattoir before studying painting and literature sporadically around England, working in Spain, Mexico, Italy, Germany, and New York, and finally finishing a doctorate at Oxford. He has published eleven books of his own poetry and five in collaboration, screened his short film, *Drift*, and continues to paint, exhibiting his work in the UK and USA. He has published translations from a number of languages, and written widely on translation, myth, and contemporary and Renaissance poetry. He currently teaches at the University of Hull.

The Writer's Brush

KAHLIL **GIBRAN** (1883–1931) the author of the perennial spiritual bestseller, *The Prophet* (1923), among many other books of verse and prose, was born in Bechari, Lebanon and emigrated with his mother and siblings to Boston, where he entered the public schools. By 1909 he was studying with Rodin at the Academy of Fine Arts in Paris, and his elegant art certainly shows the influence of the Rodin/Carriere axis.

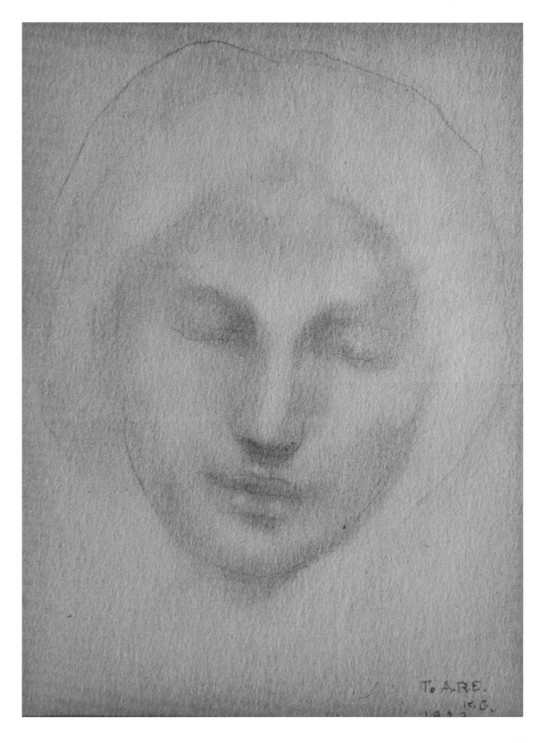

right:
Kahlil Gibran
Untitled Portrait, 1923
Pencil on paper
6" x 4 ½"
Courtesy of Denenberg Fine Arts

CHARLOTTE PERKINS GILMAN (1860-1935)

was born in Hartford, CT and grew up among her mother and paternal aunts, the suffragettes, Isabella Beecher Hooker and Catharine Beecher, and the author, Harriet Beecher Stowe. She attended the Rhode Island School of Design and supported herself as a painter and an artist of trade cards. A lifelong poet, essayist, and prose writer, her story, "The Yellow Wallpaper," catapulted her onto the national stage, lecturing on women's rights and utopian social reform. Her 1898 work, *Women and Economics*, a critique of the social strata of domesticity and a call for the economic independence of women, made her world famous.

above:
Charlotte Perkins Gilman
Three Ages of Women, c. 1890s
Chromolithographs on cardstock
each 2 ¾" x 5"

ALLEN GINSBERG

(1926–1997) Beat icon, the best known poet of his day, was born in Newark, New Jersey, and grew up in Paterson, home of William Carlos Williams, who became his mentor. Legendary for his opposition to militarism, capitalism, and conformity Ginsberg brought all those themes together in his epic poem *Howl*, the subject of a monumental obscenity trial. In the years following he won recognition and acceptance from the literary establishment, winning the National Book Award for poetry in 1974 for *The Fall of America*, and in 1979 was inducted into the American Academy and Institute of Arts and Letters. In 1995 he won a Pulitzer Prize for *Cosmopolitan Greetings: Poems 1986–1992*.

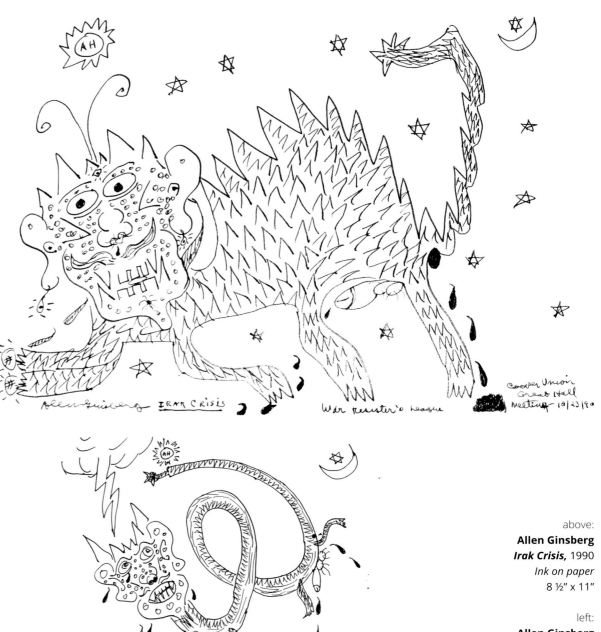

above:
Allen Ginsberg
Irak Crisis, 1990
Ink on paper
8 ½" x 11"

left:
Allen Ginsberg
The Spirit of American Conservation, 1991
Ink on paper
8 ½" x 11"

LOUISE **GLÜCK** (1943–) was born in New York City, and grew up on Long Island. She attended Sarah Lawrence College and Columbia University, and has received a number of Guggenheim fellowships. Her first book, *Firstborn* (1968) received the American Academy of Poets Award, *The Triumph of Achilles* (1985) the National Book Critics Circle Award, *Wild Iris* (1993) the Pulitzer Prize. She received the Bollingen Prize for lifetime achievement in 2001 and was appointed Poet Laureate of the United States in 2003-2004.

GÜNTER **GRASS** (1927–)

was born in Danzig (now Gdansk). As a teenager, in the waning days of World War II, he served in the Waffen SS as an infantryman, was wounded and captured by the Americans. Ambitious first as a sculptor, he worked as a stonemason and studied at Academy of Art in Dusseldorf from 1947 to 1952. With the publication of his first novel, *Die Blechtrommel* (*The Tin Drum*) in 1959 he became internationally famous and has remained so, publishing poems, plays, and essays, as well as other novels, and winning the Nobel Prize for Literature in 1999. He has drawn, painted, and made many engravings and lithographs energetically throughout his long career, and has illustrated a number of his own books.

above:
Günter Grass
Butt über Land, 1978
Etching on paper
9 ½″ x 14 ½″

left:
Günter Grass
In Holz Gebettet Calcuta, 1987
Sepia ink on paper
19 ½″ x 25 ¼″
Both courtesy of Steven Kasher Galler

"Listen, you owe me an explanation. We've had such great times together - you're beautiful - you know I love you - and now you dont want to see me again. Why? Why?
" Jings, you take everything very seriously."

"Fuck who you like but the rent is overdue and the electricity is going to be cut off and we've no food and the baby is hungry."
"Our love once meant much more to me than money so I'm not giving you any."

above:
Alasdair Gray
Domestic Conversation,
2006
Silkscreen print
15" x 22 ½"

left:
Alasdair Gray
Leviathan, 1981
Silkscreen Print
14" x 10"
Both courtesy of the Artist

ALASDAIR **GRAY** (1934–) was born in Riddrie, East Glasgow into a working class family. His monumental first novel *Lanark*, was written over a period of 30 years and published in 1981. Anthony Burgess called him "the greatest Scottish novelist since Walter Scott." His early education was haphazard, but he studied at Glasgow Art School from 1952 to 1957, and stayed on as a teacher until 1962, afterwards supporting himself as a portrait painter. His 1992 novel, *Poor Things*, won the Whitbread Novel Award and the Guardian Fiction Prize. He illustrates and plays with the typography of his written works, continues to paint, including a ceiling mural for Glasgow's Auditorium of the Oran Mor, one of the largest pieces of art in Scotland.

NICOLÁS **GUILLÉN** (1902–1989) was born

in Camagüey, Cuba. He abandoned legal studies at the University of Havana to concentrate on his poetry, supporting himself as a journalist. In his first volume of poetry, *Motivos de son* (1930), he combined European poetic traditions with the onomonapoesis of Afro-Cuban drumming and the rhythms of *Son*. It was widely popular and effectively sealed Afro-Caribbean culture's place in the international community. Outspoken politically, and officially a communist since 1940, he was jailed multiple times and finally exiled by the Batista government. When Castro took power in 1959, he welcomed Guillén as a hero, naming him the national poet of revolutionary Cuba and appointed him president of the National Cuban Writers' Union.

NIKOLAI **GUMILEV** (1886–1921) was

born in Kronstadt and raised in St. Petersburg. He attended the Tsarkoe Lyceum directed by the poet and classicist Innokenty Annensky to whom he remained indebted throughout his life. In 1909 he founded the art and literary journal *Apollon*, a landmark in the establishment of Russian modernism. He was a notable literary critic and theorist, a poet of exotic and romantic adventure, a wide-ranging translator, and the driving force behind Acmeism. In 1910 he married Anna Akhmatova. In 1914 he enlisted in the Russian Imperial army. He was executed by firing squad in 1921.

above left:
Nicolás Guillén
Untitled, 1964
Ink on canvas
4 ½" x 6"

above right:
Nikolai Gumilev
Persia, 1924
Ink on paper
9" x 14 ½"

Private Collection

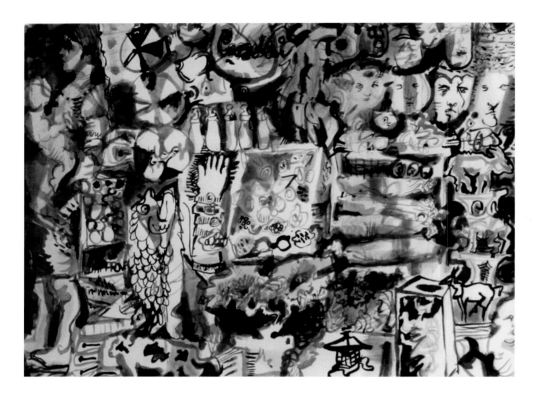

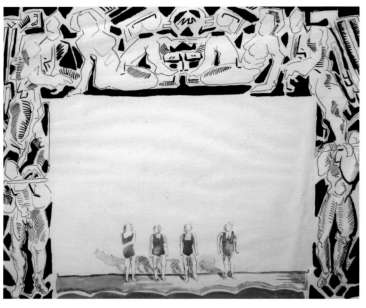

ALLAN **GURGANUS** (1947–) novelist, short story writer and essayist, was born in Rocky Mount, North Carolina and studied painting at the University of Pennsylvania and the Pennsylvania Academy of Fine Arts, and has illustrated three limited editions of his fiction. He began writing while in the navy during the Vietnam War, but did not publish a novel until he was forty-four, when his best-selling *Oldest Living Confederate Widow Tells All* appeared.

BRION **GYSON** (1916–1986) was born in

Taplow, Buckinghamshire, outside London. A writer, painter, and musician, he experimented with the cutup technique first employed by Tristan Tzara, sharing it with William S. Burroughs with whom he was living in Paris in 1959. Burroughs then utilized it to great effect in his prose. Gyson also applied the cut-up technique to what he called permutation poetry and recording – poems in which the words of a single sentence or phrase would be repeated, each time with the words in a different order, and at least one recording in which the firing of a gun was recorded at different distances and then spliced together.

above left:
Brion Gysin
Untitled, 1963
Watercolor on paper
Private Collection

above right:
Brion Gysin
Untitled, 1963
Watercolor on paper
Private Collection

above:
Donald Harrington
William and Rose Styron, c. 1970
Oil on Canvas
approx. 30" x 40"

Courtesy of Rose Styron

DONALD **HARRINGTON** (1935–2009) was born in Little Rock, Arkansas. He grew up in Little Rock and the nearby Ozark Mountains, where he nearly lost his hearing at age twelve due to meningitis, and where he heard the Ozark folk tales and language that gave shape and setting to his novels. Writing since he was able, he felt his professional life shouldn't interfere with his vocation, and so studied art and art history, lecturing in New York, New England, South Dakota, and finally back at the University of Arkansas. He wrote more than sixteen novels and art historical works, and was awarded the *Robert Penn Warren Award.*

HERMANN HESSE (1877–1962) winner

of the 1954 Nobel Prize for Literature was born in the town of Calw, Wurttemburg, Germany. Among his notable works are *Steppenwolf*, *Siddhartha*, and *Magister Ludi* (*The Glass Bead Game*). His books which are shot through with the issues of individualism, spirituality and the quest for enlightenment, found a new audience in the counter-cultural movements of the 1960's. He was a devoted and accomplished painter, largely of miniatures, throughout his life.

above left:
Herman Hesse
Blauer Schmetterling, c. 1935
Watercolor on paper
7" x 6"

above right:
Herman Hesse
Einsamer Abend, c. 1935
Watercolor on paper
7" x 6"

below left:
Herman Hesse
Rueckgedenken, c. 1935
Watercolor on paper
7" x 6"

below right:
Herman Hesse
Traum von Dir, c. 1935
Watercolor on paper
7" x 6"

All Private Collection

left:
Jack Hirschman
Untitled, c. 1963
Acrylic on Paper
approx. 25" x 15"

JACK **HIRSCHMAN** (1933–) was born in New York, received a BA from City College, then a Masters and Ph.D. from Indiana University in 1957 and 1961. He has authored more than 50 volumes of poems and essays, including what is regarded by an astute if typically negligible readership as one of the great events in contemporary letters, his 1000-page masterpiece *The Arcanes*, and has translated dozens of books into English from German, French, Spanish, Italian, Russian, Albanian, and Greek, including the poetry of the young Joseph Stalin.

SUSAN **HOWE** (1937-) was born in Boston, her mother an Irish playwright and actor with the Abbey Theatre, her father a professor at Harvard Law School. Howe graduated from Boston Museum School of Fine Arts in 1962, and married sculptor David Von Schlegel. She has authored many books of poetry and criticism, and from 1989 to 2006 taught English at SUNY Buffalo. She also acted and worked as an assistant director with the Gate Theatre, Dublin.

above:
Susan Howe
Untitled, n.d
Collage and watercolor on paper
22" x 30"
Courtesy of the Artist

a Yves Poupard-Lieussou
bonne année 74

G.H. 72

GEORGES **HUGNET** (1906–1974) was

born in Paris but spent most of his early life in Buenos Aires, returning to France for schooling in 1913. He was associated with the Surrealists in 1926 and joined officially until banned by movement founder André Breton in 1939. Hugnet was a poet and playwright and designer of many extraordinary, and even landmark, Surrealist publications, and established the publishing company Les Editions de la Montagne.

VICTOR **HUGO** (1802–1885) arguably the greatest

poet in the French language, was born in Besancon, the son of a general in Napoleon's army. Internationally renowned throughout his life for his idealistic politics as well as his literary work, he is remembered today primarily for his novels *Les Miserables*, and *Notre Dame de Paris* (titled in English as *The Hunchback of Notre Dame*). He is said to have taken to the brush chiefly during periods of writer's block (which his output makes it quite difficult to imagine he suffered), and he can be said without exaggeration to have been among the most advanced painters in the Europe of his day, both a proto-Impressionist and something of a bridge between Goya and the Symbolists (notably Redon). He was known to modify photographs with gouache in a strikingly modern manner – and had he devoted himself exclusively to visual art, it is quite possible that he would be regarded as among the most extraordinary artists in history. Numerous monographs have been devoted to his visual work, and much of it can still be seen at his residence at 6 Place des Vosges.

above left:
Georges Hugnet
Untitled, 2007
Pastel on paper
13" x 10"

above:
Victor Hugo
Paysage Urbain, 2007
Ink, watercolor
wash on paper
2 ½" x 4 ½"

Robert Miller Gallery, New York;
Pierre Menard Gallery,
Cambridge, Mass.

The Writer's Brush

above:
Aldous Huxley
The Living Room at Sonary, 1937
Oil on canvas
27" x 21"

above right:
Aldous Huxley
Maria Nys Huxley at Siesta, 1932
Pastel on paper
24" x 30"
Courtesy of Tessa and Trevor Huxley

ALDOUS **HUXLEY** (1864–1963) was born in Godalming, Surrey, U.K., into the fourth generation of the illustrious Huxley family. He attended Eton and Balliol College, Oxford. He wrote brilliantly in every form, was a novelist, essayist, short story writer, poet, playwright, travel writer, and film script writer. He is however best known for his dystopian novel *Brave New World*, for his mystical writings, especially *The Doors of Perception*, and for his experiments with hallucinogens.

TAMA JANOWITZ (1957–) novelist and short story writer dubbed one of the "brat pack authors along with Bret Easton Ellis and Jay McInerney, was born in San Francisco but at ten moved to Massachusetts with her mother. She earned a B.A. from Barnard College in 1977, and an M.A. from Hollins College in 1979, between which she did a stint as the assistant art director at Kenyon and Eckhardt, Boston. With seven novels published it is her 1986 story collection *Slaves of New York* for which she is best known. It was made into a 1989 movie directed by James Ivory.

REYNALDO JIMENÉZ (1959–) was born in Lima, Perú, and has been living in Buenos Aires since 1963. He is a writer, editor, translator, and performer, and has published nine books of poetry, two of prose, and edited multiple anthologies, including a book of Brazilian poems translated from the Portuguese. From 1983-1986 he edited the collection *Trocadero* with Violeta Lubarsky, featuring their translations of Sylvia Plath, Patti Smith, and Laurie Anderson. He is currently an editor at the journal and imprint, *Tsé-Tsé*, and records music and videopoems.

TED JOANS (1928–2003) was a poet, artist, and trumpet player. He was born in Cairo, Illinois and graduated from the University of Indiana with a degree in Fine Arts. André Breton proclaimed him a Surrealist; he was also associated with the Beat Generation and roomed with Charlie Parker. He published more than eleven works of poetry and read his work in nearly every African country; and lived in various European and African countries, as well as in the United States. As an artist he invented the photographic technique of outagraphy, and his famous painting of Parker, "Bird Lives", hangs in the De Young museum in San Francisco..

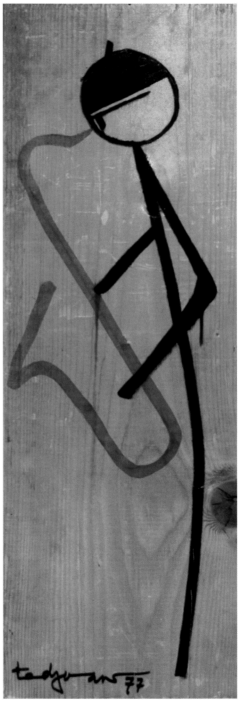

opposite:
Tama Janowitz
Baird Jones, 2007
Mixed Media collage on paper
18 ½" x 13"
Courtesy of Donald Friedman

left:
Reynaldo Jimenéz
Untitled, 1989
Ink on paper
8 ½" x 11"

right:
Ted Joans
Untitled, 1977
Acrylic on board
Courtesy of Nudel Books

CHARLES **JOHNSON** (1948–) was born in Evanston, Illinois, earned a B.S. and M.A. at Southern Illinois University and a Ph.D. in Philosophy at S.U.N.Y., Stony Brook. An elegant and deeply thoughtful novelist and essayist, he is best known for his National Book Award-winning novel *The Middle Passage* (1990), but has also enjoyed recognition for a career in cartooning with more than 1000 published in various newspapers and magazines. A professor at the University of Washington, Seattle, he won a Mac Arthur Fellowship in 1998.

The Writer's Brush

DONALD JUSTICE (1924–2005) the Pulitzer and Bollingen Prize-winning poet, essayist, librettist, and composer, and famed professor at University of Iowa's Writer's Workshop, was born in Miami. He began painting only when he was nearly sixty.

above:
Donald Justice
Courtyard at the Biltmore Hotel, n.d.
Acrylic on canvas
30" x 24"

right:
Donald Justice
City Scene, n.d.
Acrylic on canvas
39 ¾" x 30"
Both courtesy of Peggy Wier

Donald Justice
Lawn Party at Yaddo, n.d.

Acrylic on canvas
23" x 26"
Collection of Jean Justice

The Writer's Brush

ANNA **KAVAN** (1901-1968) was born Helen Emily Woods in Cannes into a wealthy British family. Her first books were published under her married name Helen Ferguson, but later adopted the name Anna Kaven, a character in her novel *A Stranger Still,* and all of her subsequent works – experimental and intensely psychological – appeared under that name, although the Library of Congress lists all her works under "Helen Edmonds," her second married name. A heroin addict who attempted suicide a number of times, she died of heart failure. She was a serious and talented painter as well as a writer, and much of her art resides at the University of Tulsa with her papers.

above left:
Anna Kavan
Seaweed Woman, 1970
Watercolor on paper
20" x 14"
Collection of Donald Friedman

above right:
Anna Kavan
Lobster Woman, 1970
Watercolor on paper
14" x 10"
Collection of Donald Friedman

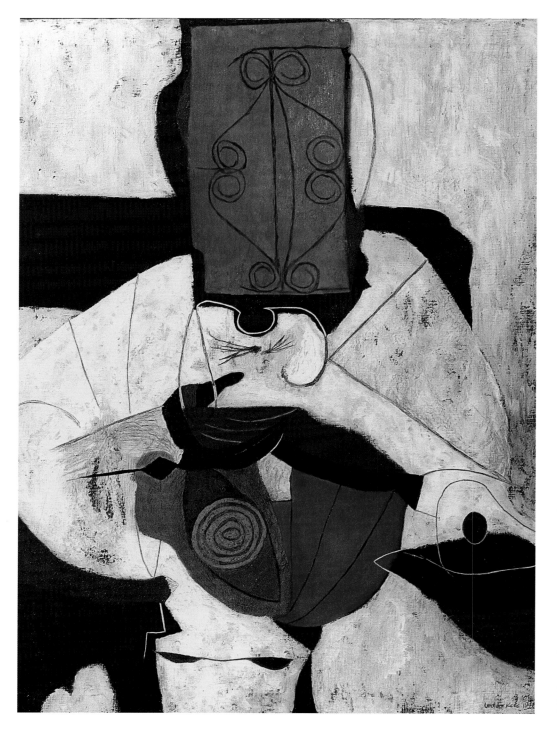

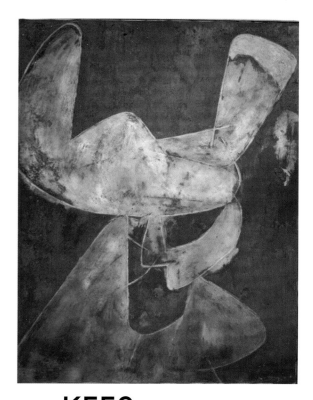

WELDON KEES (1914-1955?) was born in Beatrice, Nebraska, graduated from the State University at Lincoln, and disappeared in 1955, apparently jumping from the Golden Gate Bridge in San Francisco. A versatile figure who wrote in a variety of genres, composed music, made experimental films, and painted, he was little known to the general public during his lifetime, though acquainted with many of the great art and literary figures of the day. His novel *Fall Quarter*, was published nearly fifty years after its completion in 1941, and a *Collected Poems* was published in 1960. He received some recognition as an abstract expressionist painter even during his lifetime, with solo shows at Peridot Gallery and the Palace of the Legion of Honor, in San Francisco and well as a place in important group shows at Samuel Kootz Gallery. His work was also included in the Whitney Annuals of 1949 and 1950. His is a distinctive voice in the abstract expressionist legacy, and perhaps the last significant artist of the group to remain almost utterly obscure.

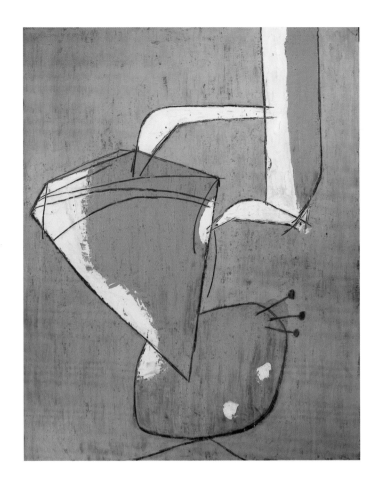

opposite left:
Weldon Kees
Abstraction (Seated Woman), 1946
Oil on canvas
43" x 32"
Gertrude Stein Gallery New York

opposite right:
Weldon Kees
Four A.M., 1949
Oil and sand emulsion on canvas
48" x 36"
Gertrude Stein Gallery New York

above:
Daniel Clowes
The Studio, 1948
Oil and sand on canvas
9" x 12"

right:
Weldon Kees
T, c. 1949
Oil on canvas
28" x 24"
Gertrude Stein Gallery New York

ROBERT **KELLY** (1935–) was born in Brooklyn, graduated from City College, and studied at Columbia. He has published more than fifty books of poetry and prose, and has worked as a translator and teacher at many institutions, most notably Bard College, where he has worked since 1961. He is also a contributing editor to *Conjunctions.* His work, associated with the Deep Image group, is always interested in the same formal tension between exactness and possibility explored in the visual arts, and frequently features collaborations with visual artists.

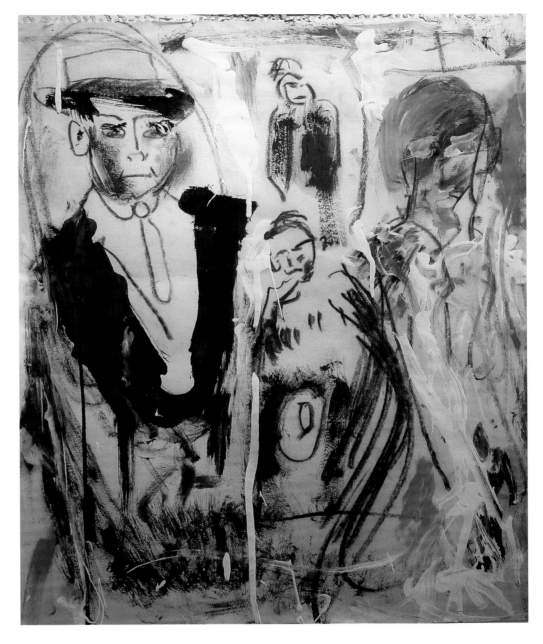

JACK **KEROUAC** (1922–1969) was born
in Lowell, Massachusetts and attended Columbia University on a
football scholarship. His work is the epitome and the record of the
Beat Generation. Taught to draw by his older brother who died
young, and always friendly with painters such as Larry Rivers, Jack
Tworkov, and Willem De Kooning, Kerouac painted and sketched
throughout his life.

KEN **KESEY** (1937–2001) was born in Colorado, but his family soon relocated to Oregon where he attended the state university. On graduation he pursued a Woodrow Wilson National Fellowship at Stanford where, studying under Wallace Stegner, he began his first and most famous book, *One Flew Over the Cuckoo's Nest* (1962), inspired by his night shift job at the Menlo Park V.A. Hospital. Publication of his second novel, *Sometimes a Great Notion* (1964) required his presence in New York and getting there inspired the famous bus trip chronicled in Tom Wolfe's *The Electric Kool-Aid Acid Test*.

right:
Ken Kesey
Acid Test, c. 1966
Lithograph on paper
23" x 17 ¾"
Courtesy of Donald Friedman

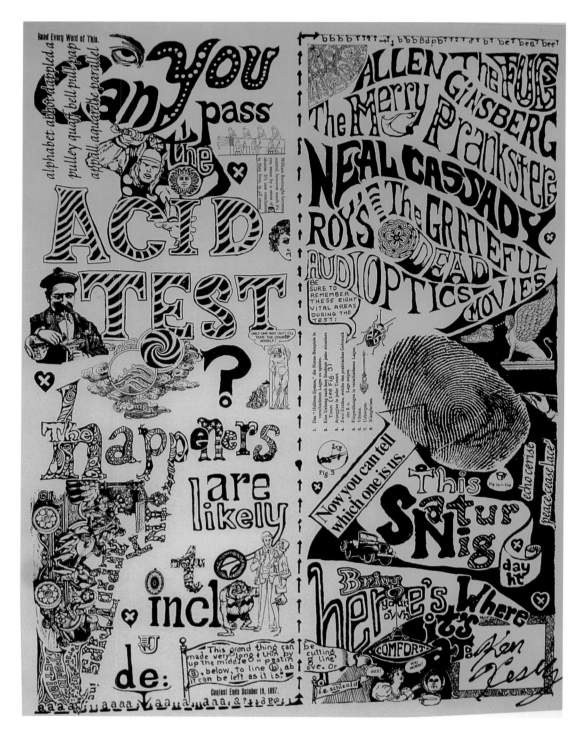

MAXINE HONG **KINGSTON** (1940–)

was born in Stockton, California, graduated from the University of California, Berkeley and taught for seventeen years in Hawaii. Her books are difficult to classify by genre, mixing fiction, myth, autobiography, poetry, and polemic. Elected to the American Academy and Institute of Arts and Letters(1990) and the American Academy of Arts and Sciences (1992), she has won a number of major awards.

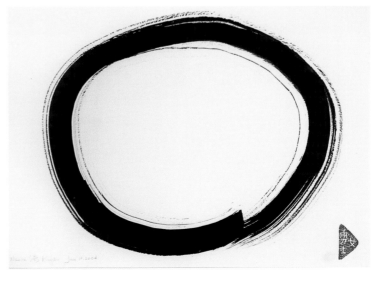

above:
Maxine Hong Kingston
The Koolaus, n.d.
Watercolor on paper
5 ½" x 12"
Courtesy of the Artist

left:
Maxine Hong Kingston
Ensō, n.d.
Ink on paper
8 ½" x 11"
Courtesy of Donald Friedman

NICHOLAS **KILMER** (1941-) is a painter, writer, editor and art dealer born in Washington, DC. He received an B.A. at Georgetown and an M.A. from Harvard, both in English. He is the author of a series of art mysteries and a number of books and art catalogues, including a memoir about the Normandy home of his grandfather, impressionist painter Frederick Carl Frieseke, whose catalogue raisonne he is editing. Kilmer's poems and translations have appeared in *The Paris Review, Western Humanities Review, Salmagundi,* and *Arion.* His art has been exhibited around the United States and is held in numerous private collections and in the collection of the Telfair Museum of Art in Savannah, GA.

BILL KNOTT (1940–) a student of poet John
Logan, was born in Carson City, Michigan, and got his M.A.
from Norwich University, Northfield, Vermont. He achieved
recognition with his first book of poems, *The Naomi Poems: Corpse
and Beans*, in 1968 published under the name Saint Geraud, who
it was claimed had killed himself two years prior to publication.
One of the purest and most tortured voices in contemporary
American letters, Knott has been writing prolifically in recent
years, but eschewing the publishing mainstream and issuing
his books, sometimes illustrated with his own art, on his own
initiative, often distributing them free of charge.

left:
Bill Knott
Untitled, 2004
Mixed Media on paper
11" x 8 ½"

right:
Bill Knott
Untitled, 2006
Mixed Media collage on paper
12" x 7"
Courtesy of the Artist

ALFRED **KUBIN** (1877–1959) was born in Bohemia, in what was then the Austro-Hungarian Empire and spent his early years focused on art studies and came for a time to be associated with the Blue Rider group of avant-garde artists. He illustrated books by great writers, and authored at least eight works of his own, most notably an apocalyptic novel *Die andere Seite* (The Other Side) set in an imagined dystopian world. He managed to work through the Anschluss and the war when his work was declared "degenerate" and was awarded the Great Austrian State Prize in 1951.

this page:
Alfred Kubin
Three Postcards, 1920
Ink on postcards
each 4" x 6"
Courtesy of Steven Schuyler

The Writer's Brush

D.H. LAWRENCE (1885–1930) was born the son of a coal miner in Nottinghamshire, England. A major novelist, and an equally great poet, he produced distinguished work in virtually every literary genre. He didn't begin painting in earnest until he was forty when it became a consuming passion.

right:
D.H. Lawrence
Rape of the Sabine Women, c. 1925
Oil on board
8 ½" x 11"
Private Collection

above:
Jonathan Lethem
Untitled, c. 1983
Oil on canvas
46" x 42"

Courtesy of Richard Lethem

above right:
Jonathan Lethem
Untitled, c. 1983
Oil on canvas
52" x 46"

JONATHAN **LETHEM** (1964–) was born in Brooklyn, New York and raised in the old, pre-gentrification, North Gowanus neighborhood. He had originally intended to follow his father, Richard Lethem, an avant-garde painter, but after leaving New York and briefly enrolling at Bennington College, he gave this ambition up in favor of writing, supporting himself with various low-paying jobs, including, horrible dictu, bookseller's mate. He has since published a number of novels and story collections, all of them imbued with his peculiarly intelligent devotion to popular culture from punk rock, to science fiction, Hollywood classics, and detective novels. He no longer paints, and all his artwork dates from his early years.

PIERRE LOUŸS (1870–1925) was born Pierre Louis in Ghent, Belgium, but grew up in Paris, attending the École Alsacienne with André Gide, a lifelong friend. He later befriended Oscar Wilde, and through his circle, developed an interest in the Parnassian and Symbolist styles, using them largely to honor erotic themes. Maybe as an elegant nod to his heterosexuality among his largely homosexual fellows, he composed the early masterwork, *Les Chansons de Bilitius*, a collection of 143 erotic prose poems compassionately portraying female, and particularly lesbian, sexuality. His claim that he translated the work from the forgotten Bilitis, contemporary of Sappho, was completely ignored. He wrote grandiose and obscene prose and verse up to his last days; his most famous works being *Aphrodite: mœurs antiques* and the delicate *Manuel de civilité pour les petites filles à l'usage des maisons d'éducation* A very accomplished photographer, his work figured prominently in the collection of the great collector of Victorian erotic photography Graham Ovenden.

MINA LOY (1882–1966) poet, playwright, actress, artist, designer, Futurist, and radical feminist, was born in London but left school at seventeen to study art in Munich. She became an intimate of many of the leading avant-garde artists and writers of her day including Picasso, Henri Rouseau, Djuna Barnes, H.D., and Apollinaire. Her first book, a small masterpiece of modernist verse entitled, *Lunar Baedeker and Time Tables* was published in 1958.

right:
Mina Loy
Weaver, 1926
Graphite and gouache on paper
18 ½" x 11 ¾"
Courtesy of Roger Conover

The Writer's Brush

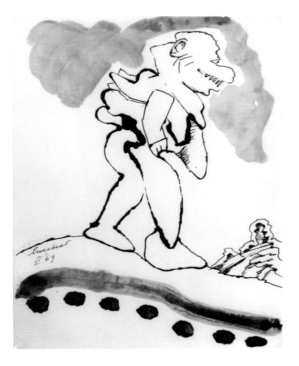

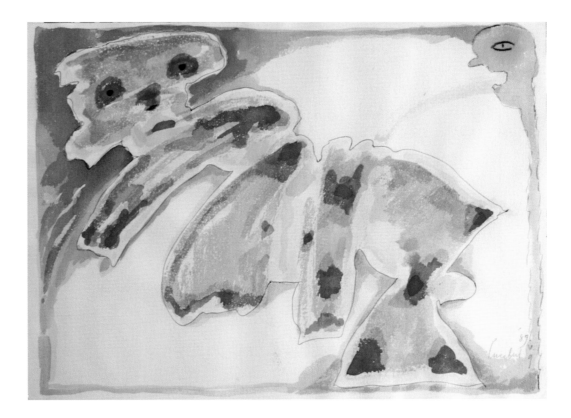

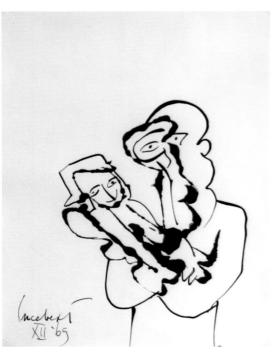

LUCEBERT (1924-1994) was born Lubertus

Jacobus Swaanswijk in Amsterdam where he was awarded a scholarship to study at the Amsterdam School of Arts and Crafts but stayed only briefly. Thereafter he became involved in the Dutch literary avant-garde, as well as the Dutch resistance, eventually achieving prominence as the "poet of COBRA." His poetry was collected in *Gedichten 1948-1965*, after which he concentrated on his painting, which is very highly regarded and which is found in, among other prominent collections, the Museum of Modern Art, New York, the Guggenheim, and the Tate Gallery, London. The poignant line from his poem "The Very Old Speaks," "Everything that is valuable is defenseless" was commandeered for advertising by a Dutch insurance company.

above:
Lucebert
Untitled, n.d.
Watercolor on paper
12" x 16"

above left:
Lucebert
Untitled, n.d.
Watercolor on paper
10 ½" x 8 ¼"

below left:
Lucebert
Untitled, n.d.
Watercolor on paper
10 ½" x 8 ¼"

Estate of the Artist

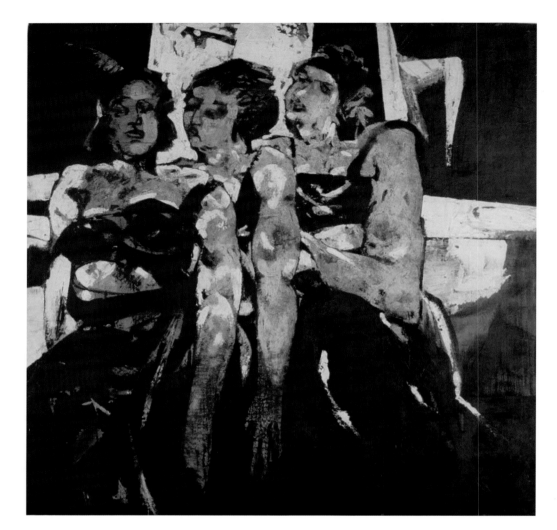

BORIS LURIE (1924–2008) born in Leningrad, suffered the great upheavals of the Twentieth Century first hand. His grandmother, mother, and sister were executed by the Nazis in the 1941 massacre at Rumbula, near Riga, and he and his father were interned at, and survived, a series of concentration camps, including Stutthof and Buchenwald. Boris Lurie was the avant-garde incarnate. NO!art, the movement he founded with Sam Goodman and Stanley Fisher in 1959, was a reaction against what they viewed as the debased avant-garde of Abstract Expressionism and its social and political disengagement. Lurie's highly controversial work, sometimes combining imagery deriving from the Holocaust with samplings from popular culture, advertising, and girlie magazines, alienated critics and curators and was ignored by the art establishment. Lurie deplored what he called the "investment art market," and he resisted its blandishments at every turn, rarely showing his art after the seventies and almost never offering it for sale. Beginning in the late sixties, Lurie began producing a voluminous collection of writings in English, German, Russian, French, and Latvian, and finished a novel, which was published posthumously, *House of Anita*, an allegory of life in the camps and an examination of the place of the artist in the post-Holocaust world in the guise of an S/M novel

opposite left:
Boris Lurie
Untitled (Three Women), c. 1955
Oil on Masonite mounted on canvas
46 ½" x 47"

opposite right:
Boris Lurie
Untitled (Dance Hall Series), c. 1955
Charcoal on paper
14 ½" x 11 ½"

right:
Boris Lurie
Lumumba is Dead, 1959-1964
Oil and collage on canvas
71 ½" x 78"

Courtesy of the Boris Lurie Art Foundation

Artwork by Writers

JULIAN **MACLAREN-ROSS**

(1912–1964) was born in London and educated mostly in the South of France. The dandy novelist was equally chronicler and mascot of the Soho demi-monde during the post-war years. He wrote a dozen books of fiction, memoires, and essays, often blurring the lines among the three. His serious treatments of film and overlooked fiction, genre and otherwise, which he boldly took up, had little precedent in the England of the 1940s and 1950s: he was an early admirer of Hitchcock and film noir, of writers like Simenon, Chandler and Hammett, Henry Green and Frank Harris; and he wrote sharp, modern, radio dramas. Though not explicitly political in his work, he was a known Labour Party sympathizer, and it's difficult in retrospect to ignore the backdrop of social strife shading nearly every move in his lifelong career of rebellion.

left:
Julian Maclaren-Ross
The Girl in the Spot-Light, 1961
Mixed Media on paper
10 ¼" x 7 ¾"
Courtesy of Peter Harrington Bookseller

opposite:
Clarence Major
Jamaica, 2003
Acrylic on canvas
30" x 30"
Courtesy of the Artist

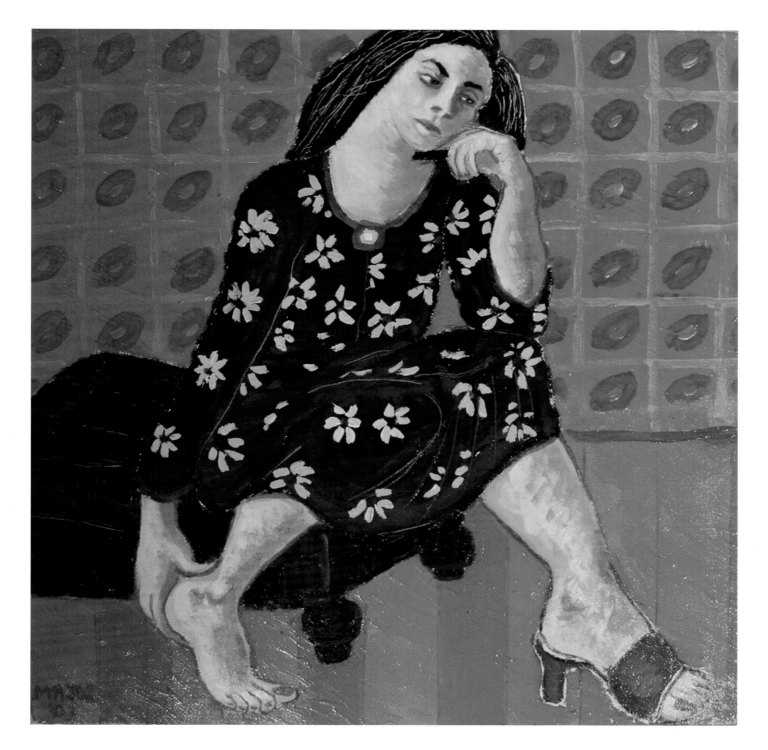

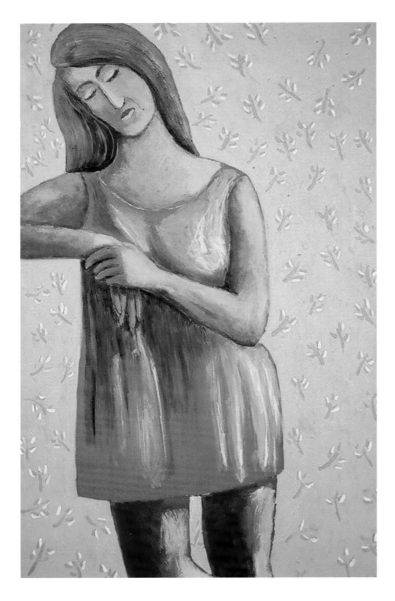

above:
Clarence Major
Joan, 2010
Acrylic on canvas
48" x 20"

Both courtesy of the Artist

right:
Clarence Major
Yolanda, 2010
Acrylic on canvas
36" x 36"

CLARENCE **MAJOR** (1936-) poet, novelist, and painter, was born in Atlanta and raised in Chicago. He earned a B.S. from S.U.N.Y. and a Ph.D. from the Union for Experimenting Colleges and Universities (now The Union Institute). He is a professor of English and Creative Writing at University of California, Davis. Among his numerous literary works is *Configurations: New and Selected Poems* (1998), a National Book Award finalist, and the recent reissue in unexpurgated form of the first of his nine novels *All Night Visitors* (1969). He studied art privately in Chicago and his paintings have appeared in a number of group and solo shows, including a recent museum show at Indiana University.

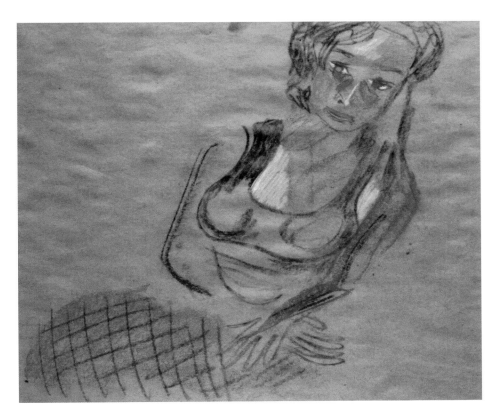

ROBERT **MARSHALL** (1960 -) says he was born on the planet Tralfamadore but admits the records show Eugene, Oregon, which is where he spent the unhappy childhood he fictionalized in his novel *A Separate Reality* (2006). He studied art at Wesleyan and after graduation in New York, but began taking fiction-writing classes at the New School in 1995 and his stories, poems, and essays began to appear in a variety of publications thereafter. Since then he has pursued parallel careers as writer and artist.

BEN **MAZER** (1964-) was born in New York City and lives in Boston. His poems have been widely published in international literary periodicals, and he has published a spate of separate volumes of poetry in recent years, including a single day on which three of his books were launched. His verse plays are without better among contemporary writers and he has edited volumes by Frederick Goddard Tuckerman, Landis Everson (winner of the first Emily Dickinson Award from the Poetry Foundation) and John Crowe Ransom, as well as several feature-length anthologies for *Fulcrum: An Annual of Poetry and Aesthetics*, where he is a contributing editor.

left:
Robert Marshall
Chain Link Fence, n.d.
Mixed Media on masonite
12" x 9"
Courtesy of the Artist

left:
Ben Mazer
Portrait of a woman, 2007
Ink on paper
8 ½" x 11"
Courtesy of the Artist

HENRI MICHAUX (1899–1984) was born in Belgium but became a French citizen in 1955. He followed a wandering life for some years, spending time in Japan, China, and India. He was equally distinguished as a poet and an artist – his expressions influenced by his exposure to Buddhism and oriental calligraphy and often produced under the influence of drugs, especially Mescaline – and a notable critic. His art accompanied several of his lifetime publications.

HENRY **MILLER** (1891–1980) was born in New York City, expatriated to Europe from 1930 to 1940 where he wrote the notorious, reputation making, *Tropic of Cancer*, and eventually settled in California. His mostly scandalous, obscene novels – less erotic than blasphemous – were available in the U.S. only after prevailing in celebrated censorship trials. Miller began painting in Paris and continued to do so passionately throughout his life. His work is widely collected.

right:
Henry Miller
Birds and Starfish, 1946-8
Watercolor and gouache on paper
18" x 12"
Courtesy of Michael Rosenfeld Gallery

above:

Henry Miller
Recital, 1943
Watercolor on paper
10" x 14"

Courtesy of Michael Rosenfeld Gallery

KATE MILLET (1934–) was born in St. Paul, Minnesota. She holds a BA from the University of Minnesota, a first-class degree with honors from St. Hilda's College, Oxford, and a PhD from Columbia University. Her 1970 book, *Sexual Politics*, became a best-seller and one of the founding documents of modern feminism. In addition to having published some eleven further books, Millett has always been active as a sculptor and artist. Her work has consistently addressed serious political and social questions, including the Vietnam War, of which she was an early protester, violence against women, oppression, and involuntary institutionalization. She has exhibited widely, most famously in the controversial *The People's Flag Show* in New York in 1970, and the landmark *A Lesbian Show,* at the 112 Green Street Workshop, generally considered the first significant exhibition devoted to art by lesbians.

above:
Kate Millett
Untitled, c. 1975
Acrylic on paper
35" x 23"
Courtesy of the Artist

left:
Susan Minot
Over El Paso en route to LA, 1999
Watercolor on paper
6″ x 4″

above right:
Susan Minot
Angata Koberi, 1997
Watercolor on paper
7″ x 9 ¾″

above:
Susan Minot
East Wisconsin Ave from the Pfister Hotel, 1999
Watercolor on paper
7″ x 9″

Courtesy of the Artist

SUSAN **MINOT** (1956–) was born in Boston, graduated from Brown University, where she studied English and painting, and earned an M.F.A. at Columbia. Her first novel *Monkeys* had a great debut, published in a dozen countries, it won the Prix Femina Etranger in France in 1987. Since then she has produced a number of novels, one of which, *Evening* (1998), was made into a movie starring Vanessa Redgrave, Natasha Richardson, and Claire Danes. Minot also co-wrote the screenplay for it as she did for Bertolucci's "Stealing Beauty." She continues to paint, always on a miniature scale, and as a private business.

BRADFORD MORROW (1951–) was born in Baltimore, raised in Denver, and lived and worked in the U.S. and abroad until he returned to do graduate work at Yale. He is the author of a half-dozen novels, the editor of several books of poetry, and since 1981 has edited the epoch-defining literary journal *Conjunctions*, which he founded. He is a professor of literature at Bard College. He abandoned what was obviously a promising career in painting in his youth.

above:
Bradford Morrow
Three Gossips, 1976
Oil on canvas
37 ½" x 52"
Courtesy of the Artist

WALTER MOSLEY

(1952–) was born in Los Angeles in 1952 and now lives in New York City. Best known for his historical crime novels set in Watts post World War II, and featuring private eye, Easy Rollins, he has also written in other genres, including science fiction, and published political and social commentary.

this page:
Walter Mosley
Untitled, 2005
Ink and watercolor on paper
each 11" x 8 ½"
Courtesy of the Artist

The Writer's Brush

VLADIMIR **NABOKOV** (1899-1977)

was born in St.Petersburg, Russia, into an aristocratic trilingual family that fled at at the outbreak of the Revolution in 1917. After a period in Western Europe, Nabokov graduated from Cambridge, then in 1923 settled in Berlin which, having a Jewish wife, he was forced to flee in 1937, arriving first in Paris and then in America. There he taught Russian at Wellesley College, and worked as a lepidopterist at Harvard's Museum of Comparative Zoology. A titan of modern letters he achieved fame and wealth with the internationally successful novel Lolita (1955). Thereafter, he retired to Switzerland.

to my dear Anuta

from the author

Vladimir Nabokov
1958 NY

ADA

Vladimir Nabokov
Montroue
June 1969

left:
Vladimir Nabokov
Inscription in _Pnin_, 1958
Colored pencil on paper
in book
Private Collection

right:
Vladimir Nabokov
Inscription in _Ada_, 1969
Colored pencil on paper
in book
Private Collection

HUGH **NISSENSEN** (1933–) was born in Brooklyn, graduated from Swarthmore College, and attended Stanford as a Wallace Stegner Literary Fellow. His stories have appeared in The New Yorker, Commentary, Harpers, and Esquire. He won the Edward Lewis Wallant Memorial Award for his first collection, *A Pile of Stones* (1965). Of his novels, *The Tree of Life* was a National Book Award and PEN/Faulkner Award Finalist.

left:
Hugh Nissenson
The Ground Beneath my Feet, n.d.
Mixed Media on canvas
20" x 16"
Courtesy of the Artist

CLIFFORD **ODETS** (1906–1963) famed

proletarian playwright, was born in Philadelphia but raised in the Bronx. He dropped out of high school to become an actor. In 1931 he co-founded the Group Theatre in New York, which produced the majority of his plays. Eventually he moved to Hollywood and became a screenwriter and a notable collector of modern art. He took up painting himself, and received a number of shows in galleries and museums.

above:
Clifford Odets
Untitled, 1946
Ink and gouache on paper
12" x 15"

above:
Clifford Odets
Coming Snow, 1947
Ink and gouache on paper
15" x 11"
Courtesy of Michael Rosenfeld Gallery

above:

Clifford Odets
Untitled, c. 1946
Oil on canvas
12" x 15"

Collection of Donald Friedman

The Writer's Brush

KENNETH PATCHEN (1911-1972) was born in Nulling, Ohio, and briefly attended the University of Wisconsin. His health was precarious, and worsened dramatically when he was struck with a debilitating spinal disease in 1937; the remainder of his life was passed in physical agony, despite which he managed to produce forty books of poetry and prose. He illustrated many of these himself, and his earliest renown was for his so-called "painted books," produced in severely limited editions.

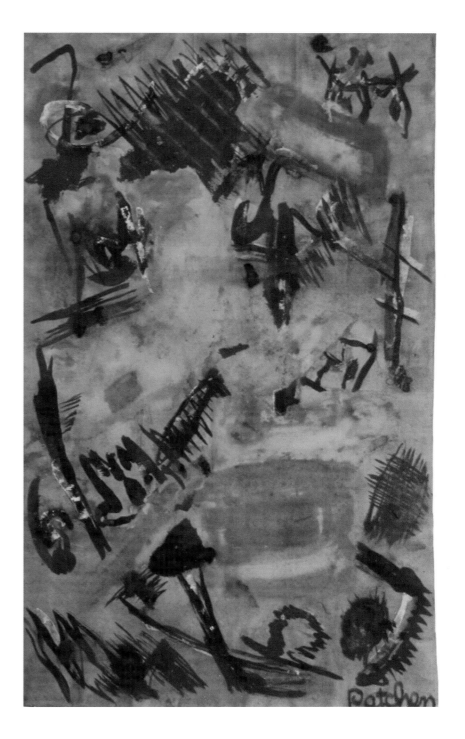

right:
Kenneth Patchen
Untitled, n.d.
Watercolor on paper
16 ¾″ x 10″
Private Collection

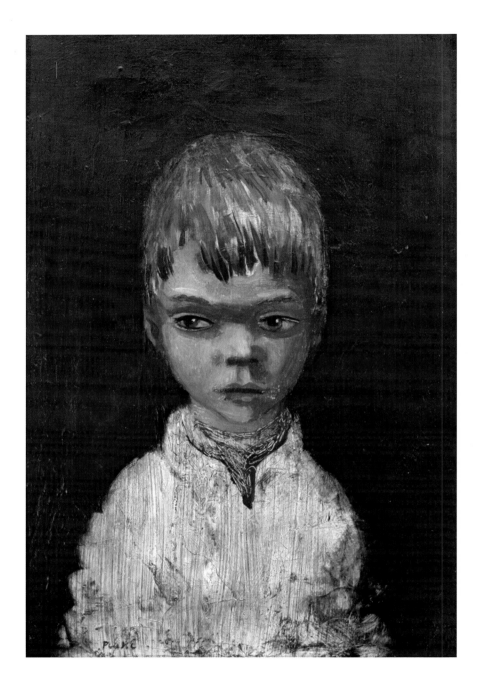

MERVYN PEAKE (1911–1968) was born in Kuling, China, the son of missionaries. He was sent to England for schooling at the age of eleven, and eventually studied art at the Royal Academies. Thereafter he settled in an artists' colony on the island of Sark. He exhibited his drawing and paintings, illustrated many children's books, wrote verse and stories for children, and eventually produced his most famous work, the *Gormenghast Trilogy*, published between 1946 and 1959.

left:
Mervyn Peake
Portrait of the Artist's Son, c. 1953
Oil on canvas
17 ¾" x 12"

CLAUDE **PÉLIEU** (1934–2002) was born in Beauchamp, Val d'Oise, France. Largely self-taught, by 18 he was living in Paris, exhibiting Cubist- and Surrealist-influenced work at the famed Galerie du Haut Pavé, and studying from time to time with Fernand Léger. In 1962 he met Mary Beach, and, spurred-on by Allen Ginsberg's *Reality Sandwiches* and encouraged by Lawrence Ferlenghetti, they moved to San Francisco to work as writers, editors, translators, and illustrators for City Lights Books. At this time Pélieu began producing volumes of poetry using William Burroughs's cut-up technique, which Beach published at her imprint, Beach Books, Texts & Documents. Married in 1975 and centered in upstate New York, Pélieu and Beach showed their collage and visual work in solo shows and together internationally, most recently at the gallery of the remarkable late bookseller John McWhinnie in New York.

above:
Claude Pélieu
American Gothic, c. 2001
Collage on paper
9" x 12"
Estate of the Artist

SYLVIA PLATH (1932–1963) was born in Boston, graduated *summa cum laude* from Smith College, and the attended Cambridge University on a Fulbright Scholarship, where she met and married poet Ted Hughes. The story of her tragic life and suicide has been told many times from many angles. Her Collected Poems were issued in 1981. As a visual artist she worked in various media and styles with considerable skill.

right:
Sylvia Plath
Self Portrait, c. 1952
Pastel on paper
26" x 19 ½"
Courtesy of Ken Lopez, Bookseller

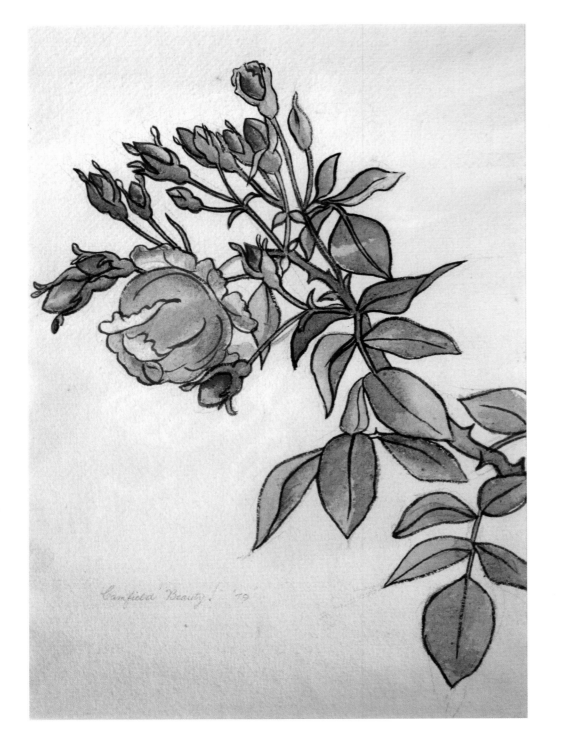

Camfield Beauty. '79

BEATRIX **POTTER** (1866–1943) was born in Kensington to wealthy parents who neglected her. Drawing, especially animals in nature, provided a respite from her loneliness and she continued the practice throughout her life. Her illustrated children's books beginning with the Peter Rabbit series, were an enormous success, and are among the most re-and-re-readable books of so few words in the language, a great charm to the weary parent.

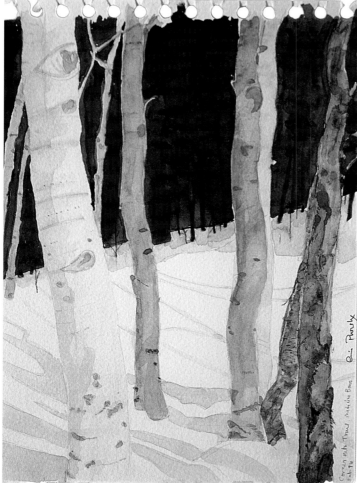

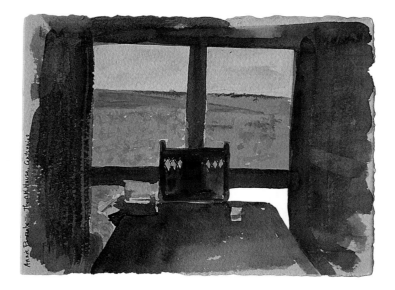

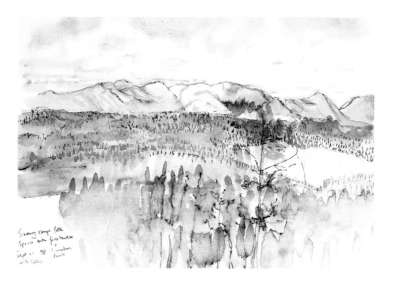

left:
Annie Proulx
Corner into Trail,
Medicine Bow, 1996
Watercolor on paper
9 ¾" x 7"

above right:
Annie Proulx
The Old House, Centennial,
c. 1995
Watercolor on paper
7" x 9"

below right:
Annie Proulx
Snowy Range from Spruce
Mtn Fire Tower, 1998
Watercolor on paper
7" x 9 ¾"

ANNIE **PROULX** (1935-) was born in
Connecticut, graduated from the University of Vermont, and currently resides in Wyoming. Her second novel, *The Shipping News*, won the Pulitzer Prize in 1993, and her short story "Brokeback Mountain" – originally published in the *New Yorker* – was made into an Academy Awarding winning motion picture. She typically uses her quite accomplished watercolors to deepen her visual sense of the landscapes in which her fictions are set, and of which they so deeply partake.

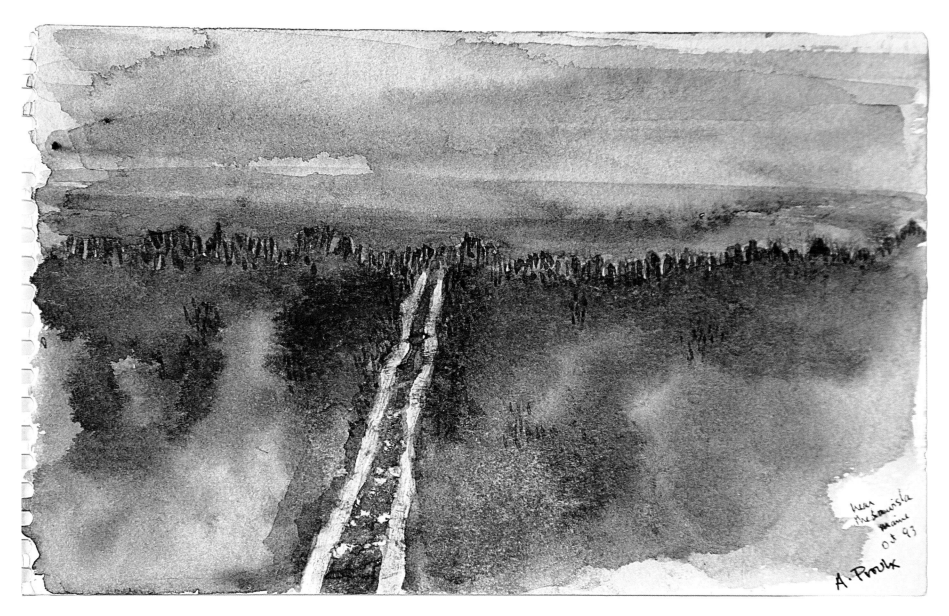

above:
Annie Proulx
Near [The bar isla] Maine, 1993
Watercolor on paper
7″ x 9 ¾″

All Courtesy of the Artist

JAMES PURDY (1914–2009) was born in Hicksville, Ohio, and educated at the University of Chicago and the University of Puebla in Mexico. A fine but neglected writer, his prodigious novels, stories, poetry, and plays are admired by a small audience of literary sophisticates, including the likes of Edith Sitwell, who "discovered" him, Dorothy Parker, John Cowper Powys, Paul Bowles, Tennessee Williams, Edward Albee, Susan Sontag, Marianne Moore, Langston Hughes, George Steiner, Paula Fox, John Waters, Roberto Calasso, and Gore Vidal, who summarized the feelings of many in calling him "a genuine American genius." Purdy drew regularly from an early age, developing a distinctive style of continuous line drawing, examples of which illustrate a number of his books. In middle age he thought he might improve his work by taking on a bit of technique, so he enrolled in a class at the Art Students League. Upon showing his work and telling his instructor presumptive that "he had never learned to draw," the latter sagely admonished, "well then don't ruin it by learning now."

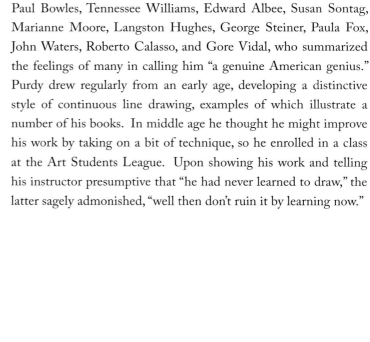

above:
James Purdy
Untitled, c. 1970
Ink on paper
10 ½" x 13 ½"

right:
James Purdy
Untitled, c. 1970
Ink on paper
8 ½" x 11"

Both Estate of the Artist

The Writer's Brush

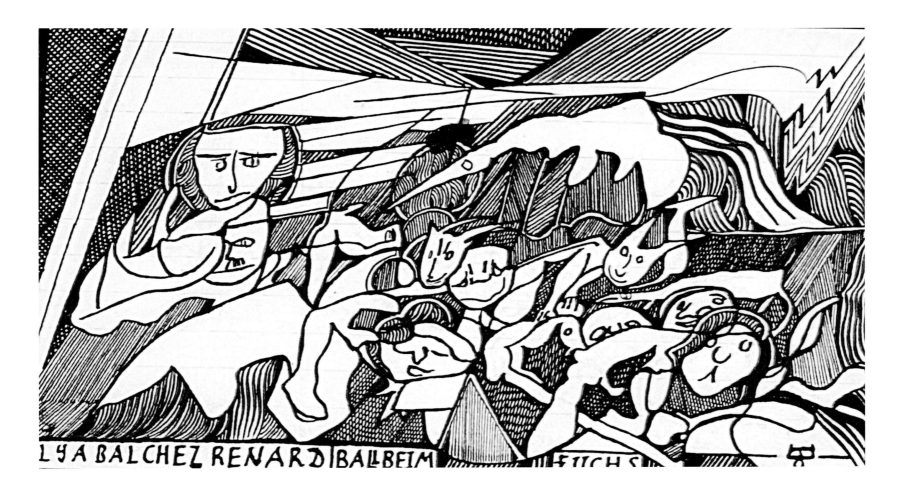

LYA BALCHEZ RENARD BALLBEIM FUCHS

ALEKSEI REMIZOV (1877–1957) was born in Moscow to a poor merchant family. For participating in the student riots in 1897 he was expelled from the University of Moscow, and exiled to Siberia, where he married a student of ancient Russian art, Serafima Dowgello. In 1905, settled in St. Petersburg, he started to imitate obscure medieval folk tales and frequent the literary and artistic salons of the Symbolist group. He had a taste for the fantastic and is distinguished by a colorful style rich in colloquial speech, which particularly influenced Isaac Babel. He left Russia in 1921, finally settling in Paris, where he continued his active career as writer, painter, and calligrapher, often creating intricate and beautiful manuscripts illuminated by his disturbing miniature ink drawings.

above:
Aleksei Remizov
Untitled, n.d.
Ink on paper
10" x 13 ½"
Private Collection

Artwork by Writers

113

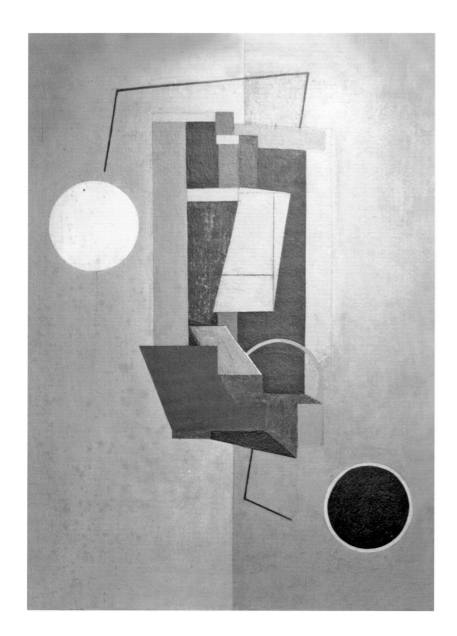

KENNETH REXROTH (1905-1982) was born in South Bend, Indiana and orphaned at thirteen. He studied panting at Chicago's New School, at the Art Institute, and later, briefly, at the Art Students League in New York. Although far more celebrated as a poet and translator than as an artist, in his very droll *Autobiographical Novel*, and in prose pieces, he insisted that both activities were equally important to him. As a painter, he moved gradually from abstraction – he was certainly among the first American artists to work in a Suprematist/Constructivist mode – to romanticism. He became a central figure in the San Francisco Renaissance and is credited by some as the father of the Beats, and by others as a primary influence on the young Richard Diebenkorn. His hefty *Complete Poems* appeared in 2002.

above:
Kenneth Rexroth
Untitled, c. 1926
Oil on board
20" x 16"
Courtesy of Kenneth Rexroth Trust

PETER SACKS (1950-) born in Port Elizabeth, South Africa graduated from Princeton, was a Rhodes Scholar at Oxford, and was awarded a Ph.D. from Yale in 1980. He has published a number of collections of his poetry, and his large abstract paintings have been exhibited in European and American galleries to wide critical acclaim, including an *Artforum* review by Rosalind Krauss.

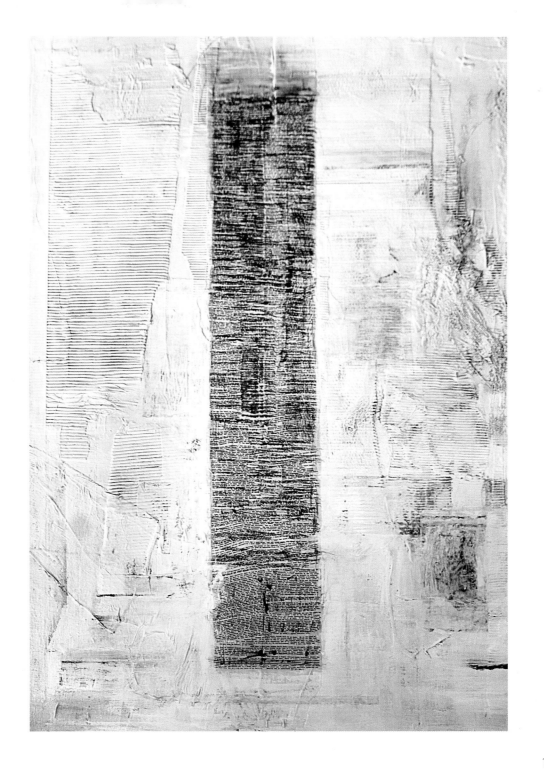

right:
Peter Sacks
Yeats, 2007
Mixed Media on canvas
76 ¾" x 51 ¼"
Courtesy of the Artist

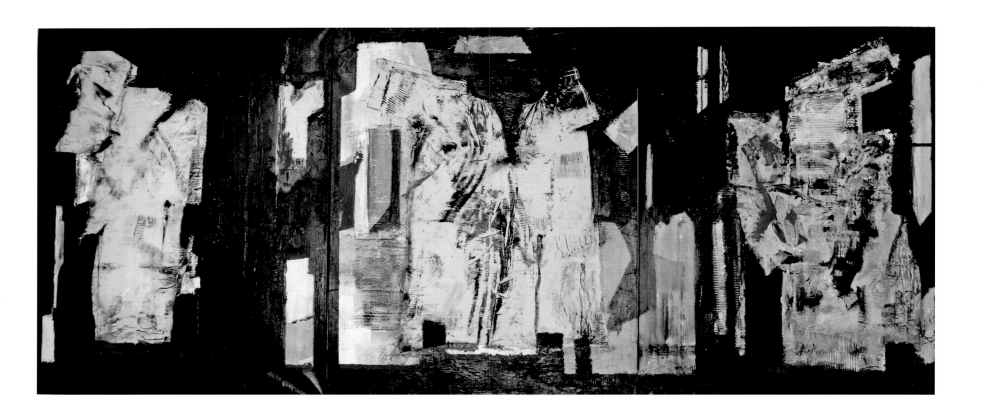

above:

Peter Sacks

Truth and Reconciliation, 2005

Mixed Media on canvas

Triptych 57 ¾" x 135"

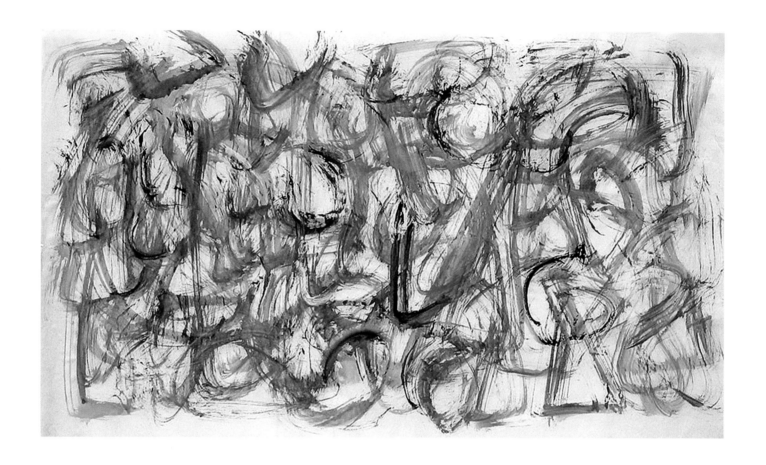

WILLIAM SAROYAN (1908–1981) the Pulitzer Prize-winning playwright was born in Fresno, California where he left school at fifteen. Thereafter, he held a variety of jobs until he found success as a writer, his career launched at 26 with his first story collection, *The Daring Young Man on the Flying Trapeze* (1934). He went on to win an Oscar for the screenplay of his 1943 autobiographical novel *The Human Comedy*. His paintings are now in the permanent collections of a number of universities and museums, including the Boston Museum of Fine Arts, and the Birmingham Museum of Art.

above:
William Saroyan
Fresno, 1967
Watercolor on paper
22" x 34"
Courtesy of Anita Shapolsky Gallery

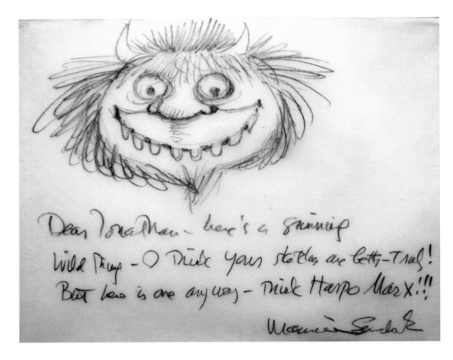

MAURICE **SENDAK** (1928–2012) perhaps

the greatest children's book author and illustrator of all time, was born in Brooklyn. He was employed solely as an illustrator before writing the highly original stories that brought him fame, beginning with the 1963 Caldecott Medal winner *Where the Wild Things Are*. Sendak has also worked successfully in the theater.

above:
Maurice Sendak
Untitled, c. 1970
Pencil on paper
8 ½″ x 11″

above:
Maurice Sendak
Untitled (Dear Jonathan),
c. 1988
Pencil on paper
3 ½″ x 5 ¾″
Both courtesy of Justin G. Schiller

The Writer's Brush

To Miss Jewett:
"Man is the rugged, lofty pine
Woman the tender clinging vine"
with the compliments
of the author.

HENRY SHUTE (1856–1943) was a lawyer and judge best known for his "Plupy" stories in the *Saturday Evening Post*, stories of bad boys in the spirit of Mark Twain and Thomas Bailey Aldrich, which were collected into two popular volumes. His third book, 1902's *The Real Diary of a Real Boy*, was a national best-seller. He wrote 18 novels and a few volumes of humorous non-fiction. He grew up in Exeter, New Hampshire, and returned there after graduating from Harvard, where he began writing in his forties, a practice he always contended was a hobby, and his success a "gigantic joke." His real passion was playing clarinet with the Exeter Brass Band.

CHARLES **SIMIC** (1938–) was born in Belgrade,
Yugoslovia, and emigrated to the United States with his family in
1953. He had early ambitions as a painter but abandoned them in
favor of a literary career. He has published many volumes of poetry
and criticism, was awarded a MacArthur Fellowship, the Pulitzer
Prize, and the Wallace Stevens Award. In 2007 he was appointed
Poet Laureate of the United States.

above:
Charles Simic
Untitled, c. 1957
Oil on wood
8" x 6"
Both courtesy of the Artist

right:
Charles Simic
Untitled, c. 1957
Oil on paper
15 ½" x 11 ½"

The Writer's Brush

PATTI SMITH (1946–) the godmother of punk rock who was inducted into the Rock and Roll Hall of Fame in 2007, is also the winner of the 2010 National Book Award for her memoir *Just Kids*. She was born in Chicago, and raised in New Jersey. Inspired by rock and roll music and a volume of Rimbaud she began writing poetry and has published eight volumes to date. She has also achieved wide recognition for her drawings, which have been exhibited in museums internationally, including the Whitney and the Museum Eki, Kyoto.

left:
Patti Smith
Safety Poster No. 1, 1972
Colored marking pen on paper
25" x 24"
Courtesy of Skyline Books, New York

WILLIAM JAY SMITH (1918–) United States Poet Laureate from 1968-1970, was born in Winnfield, Louisiana and educated at Washington University, St. Louis (B.A., and M.A), at Columbia University, and as a Rhodes Scholar at Oxford. He is the author of ten collections of poetry, two of which were finalists for the National Book Award, in addition to critical studies and translations. He was elected to the American Academy of Arts and Letters in 1975.

above:
William Jay Smith
Untitled, n.d.
Oil on wood
13" x 3 ½"
Courtesy of the Artist

IRIS **SMYLES** (1980–) is a writer and artist whose work appears in print and on-line publications of wide variety. Her stories and essays have appeared in *Nerve, BOMB, New York Press, Mr. Beller's Neighborhood, Guernica, The New Review of Literature, McSweeny's Internet Tendency*, and a variety of anthologies. After founding the web-magazine *Smyles & Fish*, she edited and wrote an afterword for *The Capricious Critic* (Otis Books, 2011), a collection of humor pieces originally commissioned for the site. A former columnist and frequent contributor to *Splice Today,* she has an M.A. from Columbia University and an M.F.A. from The City College of New York. She has a sense of humor that can only be called unique.

above:
Iris Smyles
The Naked Woman, Bar Talk, 2005
Ink on paper
4" x 6"
Courtesy of the Artist

RALPH STEADMAN (1936–) was born in Wallasey, England. He dropped out of boarding school at sixteen to work odd jobs then began cartooning after Air Force service. Besides his successful career as an illustrator, Steadman has been a prodigious writer, authoring children's books, critiques of the U.S., and the libretto of an oratorio *Plague and the Moonflower* (1998), by Richard Harvey. His is famous for his collaboration with Hunter Thompson that unleashed "gonzo journalism" on the world.

right:
Ralph Steadman
The Sheriff, 1995
Silkscreen on paper
44" x 30"
Courtesy of Origami Express

MARK STRAND (1934-) was born in Summerside, Prince Edward Island, Canada, but passed his early years moving with his family throughout the United States and Latin America. After graduating from Antioch with a B.A. in 1957, he earned a B.F.A. at Yale in 1959, where he studied painting under Josef Albers, and then an M.A. at University of Iowa, where he studied poetry under Donald Justice. Besides his more than a dozen volumes of Bollingen Prize (1993) and Pulitzer Prize (1999)-winning poetry, he has also produced Spanish and Portuguese translations and art criticism. He served as Poet Laureate of the United States from 1990-91.

Artwork by Writers

ALDO **TAMBELLINI** (1930–) is a painter, sculptor, photographer, video artist, filmmaker and poet. He was born in Syracuse, New York, and grew up in Lucca, Italy. He received a B.F.A at Syracuse University and an M.F.A in sculpture from Notre Dame before moving to New York's Lower East Side in 1959, where he founded the underground art collective, Group Center. His *Black Film Series* of the 1960s are masterworks of early experimental film, and he opened the Gate Theatre and Black Gate performance space, where his *Electromedia* performances were among the first immersive multimedia environments. He created the first work of art for television with Otto Piene, who later invited him to become a fellow at the Center for Advanced Visual Studies at MIT, where he stayed through the 1980s. As a poet, his now voluminous work maintains an active political and social commitment to peace and freedom.

above left:
Aldo Tambellini
AC-3, 1989
Acrylic on architectural paper
30" x 42"

above:
Aldo Tambellini
Destruction 21, 1961
Graphite on cardboard with incisions and burns
28" x 36"

left:
Aldo Tambellini
On Becoming 1, 1962
Acrylic and collage on paper
30" x 38 ¼"

All courtesy of the Artist

CELIA **THAXTER** (1835–1894) was born in
Portsmouth, New Hampshire, and grew up in the Isles of Shoals
where her father was a lighthouse keeper. She married and moved
to the mainland, but was unhappy there, and returned to the
Isles-specifically to Appledore-where she spent most of her life.
Depictions of the sea are omnipresent in her various volumes of
poetry and prose.

IGOR **TERENTIEV** (1892–1941) was
a Russian poet, artist, and theater producer. He worked on the
journal *LEF* with Mayakovsky and Rodchenko, with Malevich and
the Constructivists at INKhUK (Institute of Artistic Culture), and
founded the 41 Degree group with Kruchenykh, which practiced
extreme irrationality, developing a scatological semiotic program
and a theatre of the absurd. His 1927 production of Gogol's *The
Government Inspector* was noted for its grotesquerie; it included five
free-standing cubicles, one of them a toilet, and live mice.

left:
Igor Terentiev
Portrait of Aleksandr Rodchenko, n.d.
Pencil and ink on paper
16 ½" x 11 ¾"
Private Collection

above:
Celia Thaxter
Cufflinks, c. 1870s
Enamel with silver base
¾" x ½"
Courtesy of Kent Bicknell

above:

James Thurber
Carouse from *In a Word* by
Margret S. Ernst, C. 1938
Mixed Media on Canvas
11" x 8 ½"

Both estate of the Artist

above:

James Thurber
Dexterity from *In a Word* by
Margret S. Ernst, C. 1938
Mixed Media on Canvas
11" x 8 ½"

JAMES **THURBER (1894–1961)** was born
in Ohio, moved east and in 1927 began the long association with
the *New Yorker* where most of his work was first published. His
various tales and stories, essays, parables, memoirs, what have you,
all illustrated with his fluid humorous style, were gathered into
many books of considerable popularity. Perhaps the best known
single piece by him, coining a name that has passed into everyday
usage, is "The Secret Life of Walter Mitty."

128 The Writer's Brush

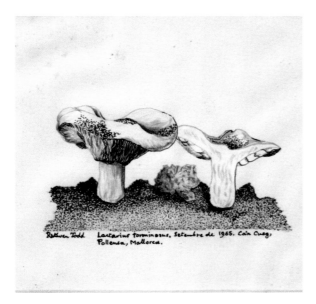

Ruthven Todd. Lactarius torminosus. Setembre de 1965. Ca'n Cueg, Pollensa, Mallorca.

Scleroderma aurantium. setembre de 1965. Ca'n Cueg, Pollensa, Mallorca. Ruthven Todd

Citocybe claviceps. Setembre de 1965. Ca'n Cueg, Pollensa, Mallorca. Ruthven Todd

Ca'n Cueg, Pollensa, Mallorca. 27 de setembre de 1965, under evergreen oak, Quercus ilex. Ruthven Todd

RUTHVEN **TODD** (1914–1978) was born in Edinburgh and educated at Fettes College and Edinburgh School of Art, where he decided he lacked all painterly originality and became fascinated with the work of William Blake. He was a pioneering editor and scholar of Blake, revering his visionary talents, as much as his productive method, which he would later incorporate into botanical drawings heightened with watercolor and intricate manuscript, and artist's books he made with noted engraver S.W. Hayter and artists like Miró. He participated in the 1936 International Surrealist Exhibition, which greatly influenced his novelistic work, often published under the pseudonym R.T. Campbell, and did a series of proto-psychedelic children's books with the *Space Cat* series of the 1950s.

above left:
Ruthven Todd
Lactarius torminosus, 1965
Ink and watercolor on paper
approx. 5" x 5"

above center:
Ruthven Todd
Scleroderma aurantium, 1965
Ink and watercolor on paper
approx. 5" x 5"

above right:
Ruthven Todd
Citocybe Claviceps, 1965
Ink and watercolor on paper
approx. 5" x 5"

left:
Ruthven Todd
Ca'n Cueg, 1965
Ink and watercolor on paper
approx. 5" x 5"

All courtesy of Adrian Dannatt

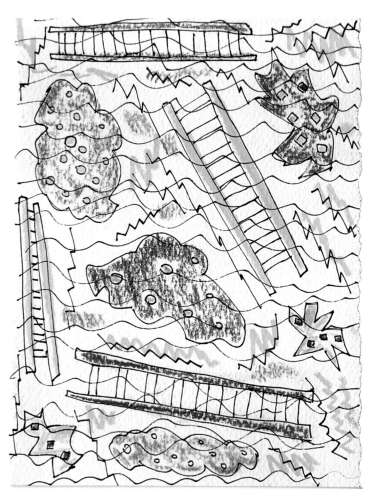

FREDERIC **TUTEN** (1936–) novelist, short story writer, and essayist, was born in the Bronx, received his undergraduate degree at City College of New York, studied pre-Columbian art at the National Autonomous University of Mexico, and earned a Ph.D. from New York University. He was the co-founder and for fifteen years the head of the graduate program in creative writing at City College. In 2001 he was honored with the Award for Distinguished Writing from the American Academy of Arts and Letters. He has worked as an art and film critic and has published catalogue essays on a number of prominent artists, including John Baldessari, Eric Fischl, and Eric Salle. His dear friend Roy Lichtenstein professed admiration for some of Tuten's small drawings which we've included in the present exhibition.

JOSEF VÁCHAL (1884–1969) was born

in Milavče, Czechoslovakia. Illegitimate, he was raised by his paternal grandparents in Písek, in Southern Bohemia, where he dropped out of school at fourteen. He moved to Prague, took up the trade of bookbinding, began to write poetry, entered the Painter School and became a respected painter and graphic designer. His first two books were published in 1910 and he went on to publish at least ten more, although frequently in only a minute number of copies, and he spent his life in isolation and obscurity – in part because of the takeover of his country by the Germans and then by revolutionary communists. Vachal can lay meaningful claim to the title of "the William Blake of the Twentieth Century," having created every aspect of many of his book-works, from the paper, to the type, to the text and images and even the extraordinary art nouveau bindings in which he encased some of the deluxe copies.

previous page left:
Josef Váchal
Landscape, 1907
Oil on compostion board
24" x 17"

previous page right:
Josef Váchal
The Tree of Life, 1910-3
Woodcut on paper
25 ½" x 15 ¾"

Courtesy of Michael Fagan Fine Arts

above left:
Josef Váchal
Zvěstovanní Panně Marii, 1925
Color woodcut on paper
11" x 10 ½"

above right:
Josef Váchal
Předostovy Bohů, 1926
Color woodcut on paper
11" x 10 ½"

JANWILLEM VAN DE WETERING
(1931–2008) was born in Rotterdam, but travelled widely and pursued studies and occupations in a number of countries before he began writing at forty. After publishing two books about his experience in a Zen monastery in Japan, and the first volumes of his now many-million-selling Amsterdam Cop series, he settled in America where he died. His early efforts in art were large constructions, then he painted, but denied formal training in either discipline.

above:
Janwillem van de Wetering
Untitled, 2006
Acrylic on board
8" x 10"

left:
Janwillem van de Wetering
Untitled, 2006
Acrylic on paper
10 ½" x 8 ½"

Courtesy of the Artist

above left:
Kurt Vonnegut
Untitled Portrait, 1985
Marking pen on paper
24″ x 19″
Courtesy of Scott Prior

right:
Kurt Vonnegut
Saab Business Man, c. 1988
Marking pen on paper
11 ¾″ x 9″
Courtesy of Origami Express

KURT **VONNEGUT** (1922–2007) an American icon, was

born in Indianapolis and attended Cornell, majoring in chemistry before enlisting in the army in 1942. Held as prisoner of war in Dresden, he was one of only seven American prisoners to survive the Allied fire-bombing of the city, and the experience inspired his most highly-regarded novel, *Slaughterhouse-Five*. In his later years he became increasingly interested in visual expression and began producing drawings, etchings, and silkscreens, which were exhibited and widely sold as prints. He once told me that, when his writing wound down, his art give him a new life.

DEREK WALCOTT (1930-) was born on the island of St. Lucia, where he continues to live at least part of the year, in 1930, and attended the University of the West Indies. Committed to the theatre throughout his career, he founded the Trinidad Theatre Workshop in 1959 where many of his own plays were first performed. He is better known, however, as a poet, and was awarded the Nobel Prize for Literature in 1992.

above:
Derek Walcott
Street in Gro Ilet, 2004
Oil on canvas
18" x 24"
Courtesy of the Artist

KEITH **WALDROP** (1932–) was born in Emporia, Kansas, attended Kansas State Teachers College and, following Army service, received a Ph.D. in Comparative Literature from University of Michigan in 1964. He has authored numerous books of poetry and prose and his translations of French poets has earned him the Chevalier des Arts et des letters from the French government. His *Transcendental Studies: A Trilogy* won the 2009 National Book Award for poetry.

The Writer's Brush

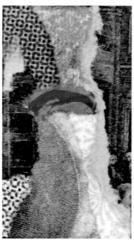

above:
Keith Waldrop
Untitled, c. 1989
Collage on paper
5" x 5 ½"

near right:
Keith Waldrop
Untitled, c. late 1980s
Collage on paper
2 ½" x 1"

far right:
Keith Waldrop
Untitled, c. 1994
Collage on paper
10" x 8"

All courtesy of the Artist

ROSANNA **WARREN** (1953–) poet and daughter of Robert Penn Warren, was born in 1953 in Fairfield, Connecticut, graduated from Yale in 1976 with a degree in painting, and earned an M.A. in writing at Johns Hopkins in 1980. She is a member of The American Academy of Arts and Letters and the American Academy of Arts and Sciences and has served as Chancellor of the Academy of American Poets. She is currently the Emma MacLachlan Metcalf Professor of the Humanities and a University Professor at Boston University.

left:
Rosanna Warren
Untitled Still-life, n.d.
Acrylic on canvas
24" x 26"

above:
Rosanna Warren
Untitled portrait, n.d.
Pencil on paper
11 ½" x 17"

Courtesy of the Artist

right:
Lewis Warsh
Untitled, 2005
Collage on paper
15″ x 20″

LEWIS WARSH (1944–) was born in the Bronx. He is the author of numerous books of poetry, fiction and autobiography. His poems have appeared in *The Best American Poetry* anthology in 1997, 2002, 2003 and he is recipient of grants from the NEA, NYFA, and The Fund for Poetry. He is co-editor of *The Angel Hair Anthology*, editor and publisher of United Artists Books, and director of the MFA program in creative writing at Long Island University in Brooklyn. His remarkable Lettrist collages have illustrated a number of his books.

DENTON WELCH (1914–1948) was born in Shanghai where his family owned a shipping and trading business. He was educated in England and entered Goldsmith's College of Art intending to become a painter. A near fatal cycling accident in Surrey left him an invalid, however, and he was unable to stand at an easel long enough to paint. He turned to literature with considerable skill, producing novels and a collection of short stories before succumbing to his injuries. A complete edition of his *Journals* was published in 1984. His unfinished, posthumously published, *A Voice Through the Clouds*, is an account of his accident and illness. He designed and illustrated his own books. Most of his paintings are in private hands, though there is a fine self-portrait in the National Portrait Gallery in London.

right:
Denton Welch
Untitled, c. 1954
Watercolor on paper
11 ½″ x 8 ¼″
Courtesy of Peter Harrington, Bookseller

140 The Writer's Brush

MARJORIE WELISH (1944–) is a poet and art critic with eight published books of poetry and criticism, most recently *Word Group* (2004). She graduated from Columbia University and Vermont College (MFA). *The Annotated "Here" and Selected Poems* (2000) was a finalist for the Lenore Marshall Prize of the American Academy of Poets. Her collected art criticism appeared in 1999 under the title *Signifying Art: Essays on Art after 1960*. A former poetry teacher at Brown University, she teaches literature and art at Pratt Institute. Her artwork is represented by Baumgartner Gallery in New York and the Aaron Galleries in Chicago.

above:
Marjorie Welish
Untitled, 2007
Acrylic on paper
11" x 14"
Courtesy of the Artist

"He says he was just playing Cupid"

RPW

RICHARD WILBUR (1921–) was born in New York City. He graduated from Amherst College and took the M.A. at Harvard. Cultivated, witty, and urbane, he was one of the most noted of the "New Formalists" who came of age after World War II. He has also translated Moliere and Racine, works that have been successfully staged. He was twice awarded the Pulitzer Prize for Poetry, in 1957 and in 1989. He was the second Poet Laureate of the United States, appointed in 1987.

above:
Richard Wilbur
Untitled (Playing Cupid), n.d.
Ink on paper
5" x 8"
Courtesy of the Artist

opposite left:
Tennessee Williams
Vision of Paraclete, 1974
Oil on canvas
30" x 24"

opposite left:
Tennessee Williams
Carnival, n.d.
Oil on canvas
20" x 16"
Courtesy of John Uecker

The Writer's Brush

TENNESEE **WILLIAMS** (1911–1983)

arguably America's greatest playwright, was born Thomas Lanier Williams in Columbus Missouri; his family's life was deeply troubled, and much of it is mirrored in his writings. Besides his renowned plays he also published two novels, collections of stories, poetry, essays, and memoirs. Williams painted all his life, and by the 1970s was exhibiting regularly and commanding respectable prices. Large collections of his work are in the Harry Ransom Center at the University of Texas and in the Rare Book and Manuscript division of Columbia University's Butler Library.

STANISŁAW IGNACY WITKIEWICZ

(1885–1939) commonly known as Witkacy, was born in Warsaw, the son of a formidable art critic and was home-schooled in Zakopane, the center of Polish artistic life. He had an adventurous youth, traveling to New Guinea and Australia with his friend, the famed anthropologist Bronislaw Malinowski, and serving as a decorated Tsarist officer. Although a painter by training and profession, he was a major novelist (*Insatiability*), and playwright, his work a precursor of theater of the absurd. A mentally unstable alcohol and drug abuser, he committed suicide as the Russian and German armies advanced on Poland. Many of his paintings and drawings were simultaneously experiments with drug use, and he would typically note on the rectos of the works just what inebriants he had consumed before embarking on them.

above:
Stanisław Ignacy Witkiewicz (Witkacy)
Zamiast Fluidu, 1932
Pencil on paper
8" x 13 ½"
Courtesy of Ubu Gallery

The Writer's Brush

above:
Stanisław Ignacy Witkiewicz (Witkacy)
Dochod Masek pod Karnawałowych, 1932
Pencil on paper
8″ x 13 ½″
Courtesy of Ubu Gallery

TOM **WOLFE** (1931–) was born Thomas Kennerly Wolfe, Jr. in Richmond, Virginia. He graduated from Washington and Lee and took a Ph.D. in American Studies at Yale. His only formal art training was a WPA art class during the depression, but ultimately he became proficient enough to illustrate his own early newspaper stories. His drawing and caricatures have been collected in a book, *In Our Time*. One of the most successful of the "New Journalists," he made a long-planned transition to fiction with *The Bonfire of the Vanities* in 1987, which was a tremendous commercial success. He has also written scathingly about modern art in *The Painted Word* (1975) and modern architecture in *From Bauhaus to Our House* (1981).

above:
Tom Wolfe
Cover for Purple Decades, c. 1982
Colored pencil on paper
16" x 12"
Courtesy of the Artist

above right:
Tom Wolfe
The Soul of the American Literaturs, c. 1980
Conte on paper
9" x 12"
Courtesy of the Artist

The Writer's Brush

WILLIAM BUTLER YEATS (1865–1936) winner of the 1923 Nobel Prize for Literature, Ireland's great poet and playwright, was born in Dublin and educated at local schools, but never attended university. His father was a professional portrait painter and taught all of his children to draw: his brother Jack became an admired modernist painter and his two sisters, Elizabeth and Susan Mary, worked in the Irish Revival's Arts and Crafts movement. While WBY did attend art school for three years, he did not continue its practice with much vigor. Most of his extant artwork is in the National Gallery in Dublin.

left:
W.B. Yeats
Untitled, c. 1870s
Watercolor, gouache, and pastel on paper
7" x 9"
Private Collection

UNICA **ZÜRN** (1916–1970) was born in Berlin and began her career writing short stories and radio plays. In 1954 she met the painter and surrealist doll maker Hans Bellmer in Paris and became his model and mistress. Along with Bellmer, she became intimate with the major surrealists, including Max Ernst, Man Ray, and Breton. She gave demonstrations of automatic writing and devised her anagramatic method of writing poetry. Her most notable book was the fantastical *Der Mann im Jamin*, recently issued in English translation by the Atlas Press. She suffered from severe depression and was hospitalized repeatedly, finally killing herself in 1970.

right:
Unica Zürn
Untitled, c. 1960
Ink on paper
14 ½″ x 11 ½″
Courtesy of Ubu Gallery

The Writer's Brush

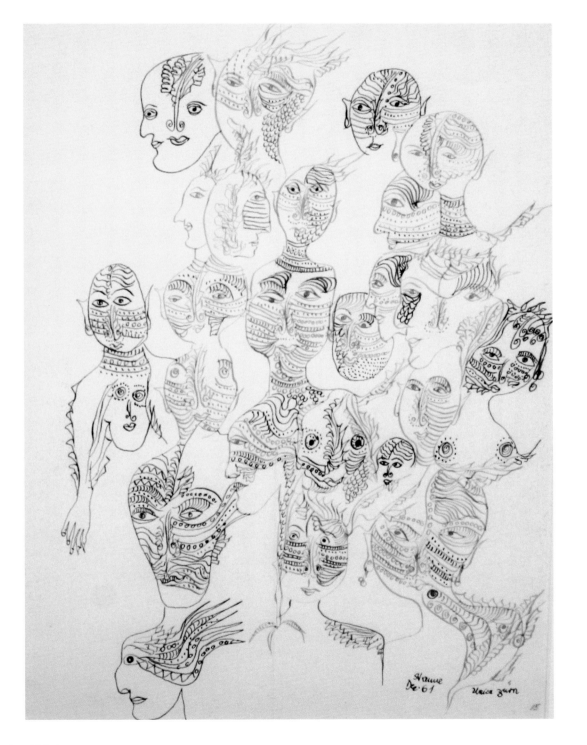

left:
Unica Zürn
Untitled, c. 1961
Ink on paper
12 ½" x 9 ¼"

Courtesy of Ubu Gallery

Artwork by Writers

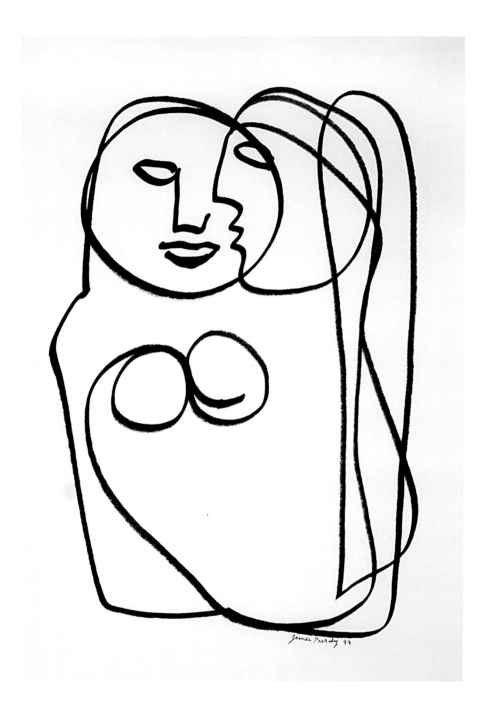

right:
James Purdy
Untitled, 1993
Charcoal on paper
24" x 18"
Estate of the Artist

150 The Writer's Brush

Afterword

John Wronoski

The Writer's Brush is an exhibition of visual works by intelligent, thoughtful, sometimes even brilliant artists who, for the most part, don't have the technical wherewithal, or perhaps more importantly, the habit of or ready facility for visual thinking, to bring their ideas to fruition in a work of art. In this respect they are like us, their readers, in relation to the fruits of their principal endeavor. Many of us, too, are intelligent, thoughtful, sometimes even brilliant, yet a vast divide separates the organization and results of our spiritual lives from those of the literary artist, no matter how passionately we might engage the written word.

Here we are inclined to marvel at work to which we might not pay a great deal of attention in another context because we know something intimate about its creators, in fact we feel as if we know them well, a feeling we almost never get in the presence of visual art, regardless of how identifiable or "branded" it is. We actively seek to find more in their efforts than there might actually be; we want them somehow to win us over. We know already that these artists have something to say, that they have thought long and deeply about the human condition, to the extent of being almost surrogate thinkers for us all, and we therefore believe that they must have infused even these often casual and amateurish productions with the power they have accrued over decades of solitude and meditation.

Painting, or visual art overall, is not, in general, a medium in which reflection thrives, and there are obvious practical, technical, socio-economic, and existential reasons for that, so we tend to dismiss or to pass over without particular notice most of its more indifferent products, configuring that realm in terms of the masterpiece rather than embracing each work on its own terms and merits, whereas we are willing to look for meaning in the visual works of a writer, even if they betray some crudeness or simplicity, almost in the way we are captivated by the efforts of our own children, seeing evidence of their dispositions in a subtle tone here, and of our hopes for them in an exuberant stroke there.

We like to think of the unrefined byproducts of the literary life as relevant to the understanding of the creations themselves, those stolid, invulnerable monuments to the human spirit: that letters, journals, abandoned drafts, and such, somehow give us insight into the work itself. And we think this in an obscurer way about such not so clearly related occasional artifacts of the writer's transit as drawings or works of art or, famously at one time, grocery lists. But does the visual work of art really offer any greater entree into that deeper part of the writer's soul to which we seem so desperately to crave access? Does it actually illuminate the literary art in a way that is not utterly conjectural? And beyond that, does even biography itself offer us meaningful insight into the literary work of art, or does the level on which art becomes meaningful not rather inherently require that the ore of experience have been mined, refined, and purified of the very dross in which we would seek it's hidden meaning? We tend to think of the archive as a physical analogue of the creator's, or perhaps better, the art's unconscious, but, in itself, the unconscious, anyone's unconscious, is insufficient to explain his or her acts, even if we could, in fact, see it before us. The innumerable moments of decision, great and small, that constitute the natural process of the growth of the work have all vanished within it, even when evidence of some of their array has been preserved in alternate drafts. The successful artwork, whether visual or literary, transcends the person of its creator, even to the extent of giving him no greater insight into its meaning than any given reader or viewer might bring to bear on it. In failing to convey its inchoate intention, the unsuccessful work falls short of the point at which meaning will have gathered and therefore remains fit only for speculation as to what might have been. The mystery of creativity, into which we imagine we might secure particular insight by analyzing these less highly-wrought, or more unguarded, works in another realm, as in the present exhibition, is only further enshrouded within them. In optimal cases, there are two mysteries instead of one.

Phylogenetically, the visual artwork, if we may be permitted to use a term that is probably almost entirely irrelevant to the visual creations of our far distant ancestors, regardless of what poignant depths of Ur-spirituality we believe we can detect in them, precedes the literary work of art, in which we can probably include the long oral traditions that led up to its emergence (again, with a similar proviso) by many millennia. Similarly, the impulse to draw precedes the far more complex activity of writing in the development of the individual. But we may reasonably surmise a consanguine if not necessarily unitary motivation in both. The urge to embrace the world without, to bring it into ourselves, and to show it back to itself first expresses itself in drawing and,

left:
Boris Lurie
Suitcase, c. 1964
(Front and Reverse)
Oil and paper collage on leather suitcase
15" x 23" x 7"
Courtesy of the Boris Lurie Art Foundation

quite naturally, later in writing. Both, of course, wither on the vine in most of us, as the developmental needs they served mature or are satisfied by any number of other particular modes of engagement with the world. The literary artist has almost always started as a visual artist, and often resorts to the earlier method when words fail her, fatigue sets in, or other dreams beset her. The visual artist hypertrophies his first voice, and very often fails to adequately develop his second. In rare cases, like ambidexterity, a facility develops equally for both.

The range of quality in the work of the literary visual artist is great, running from the underappreciated genius of a Victor Hugo or a Weldon Kees, or for that matter of an Aldo Tambellini or a Boris Lurie, two magnificent primarily visual artists who have also written enormous amounts of very interesting if largely unpublished literary work, to far less glorious efforts that have seen the light of day only in spite of their creators' best efforts to prevent it. But even their incompetence is charming and reminds us of Rodin's dismissal of inspiration and enjoinder that work is what counts in the realm of the spirit. The difference between a practice to which they've devoted their lives and one in which they occasionally engage with pleasure as an avocation or as a spur to frustration is the difference between maturity and childhood, or an occupation and a game. Most even great visual artists don't get it right more than maybe 5% of the time if they're lucky, constant effort notwithstanding. Same thing with poets: there's a lot of the less than magnificent among even the published work, because that's the nature of exploring in unknown territories of the mind (not to mention that it's simply difficult and that most lifelong practitioners never produce a single great poem or a single enduring work of art.). And when something is committed to canvas, there's basically no taking it back. It works or it doesn't, or it works to some extent, or it just misses. Sometimes-majestic artists like Tàpies, Kiefer, or Leonardo Drew give us the impression that they have been working under the influence of a god upon whom they cannot simply call at will and, when abandoned, leave the traces of their mere mortality scattered in almost random cries for help, or perhaps rather desperate sacrifices, among their art. Others such as Lee Bontecou, whose work of the sixties is certainly among the most powerful bodies of visual art in the twentieth century, make us wonder what almost idiolectic compulsion can explain the direction of her later work. If there is no guarantee that such artists can reliably remain the vehicle of genius, we can perhaps not only view the efforts of the writer/artist with critical forbearance, but maybe even recognize that the eloquent individual work is far more relevant to the history and the soul of art than the vast bodies of indifferent Picassos and Monets, their

pedigree notwithstanding. As the poet Charles Vallely, some of whose final writing is embedded throughout the present catalogue, said, "The history of literature is not an unbroken sequence of masterpieces. Most art needs to be addressed indulgently, with an understanding of its faults and shortcomings. Attempting to transcend our imprisonment in space and time, it rarely succeeds. It endures, for the most part, as the record of that struggle."

Some art might actually be enriched by the acknowledgement of its shortcomings, some elevated by the recognition of its only modest successes. We will probably never again escape the hegemony of branded art products, but in the sort of mindful viewing that art such as the present assemblage encourages, perhaps we can at least regain some of our ability to see.

In my first conversation with her, Annie Dillard, whose visual work I consider one of the delightful revelations of *The Writer's Brush*, said to me, "Do you mean to say that there are some writers who don't make art?", thereby putting the matter of the "strange case of the dually-talented artist" into quite a different perspective than that from which I'd been inclined to see it. Yes, these artists' dual facilities for expression are a wonder. A quite natural wonder.

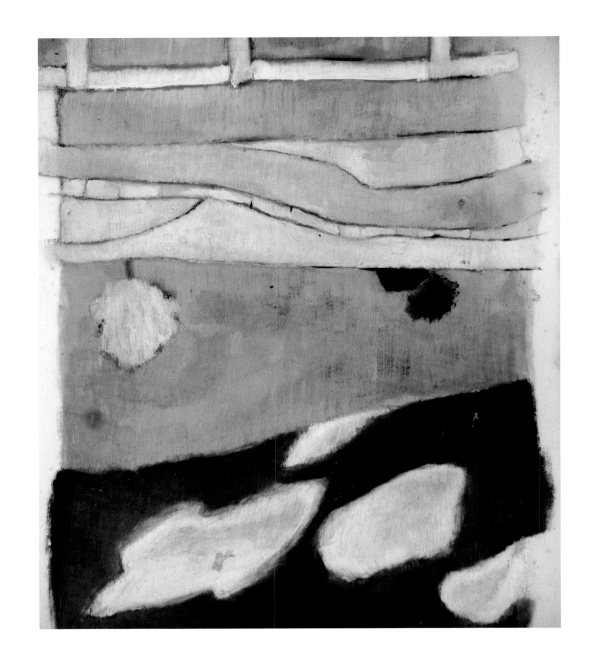

right:
Annie Dillard
Untitled, n.d.
Acrylic on board
9" × 7 ½"
Courtesy of the Artist